OLD ENGLA

AND THE

MUSICAL INSTRUMENTS MUSEUM

BRUSSELS

Eric HENNAUT • Liliane LIESENS • Anne-Marie PIRLOT

AAM
ÉDITIONS

produced by the
ARCHIVES D'ARCHITECTURE MODERNE

with the support of
LA RÉGIE DES BATIMENTS

texts and research:
Eric Hennaut, Liliane Liesens and Anne-Marie Pirlot

with the assistance of:
Anne Lauwers and Dominique Dehenain

layout and maps:
Patrick Demuylder

translation:
Martin Clissold

*The Archives d'Architecture Moderne extends its warmest thanks to all the persons
and institutions who helped make this work possible, and in particular:*
the GUS firm of architects, François Terlinden and Veerle Taekels,
the Musical Instruments Museum and Malou Haine,
the Archives de la Ville de Bruxelles and Thérèse Symons,
the Bibliothèque Royale Albert Ier in Brussels, the Crédit Communal de Belgique,
the Institut Français d'Architecture in Paris, Jérôme Bertrand, Françoise Demeuldre Coché,
Xavier Duquenne, Jean Glibert, Guy Guyon de Montlivault, Eric Jacobs,
Jacques Lemercier, Anny Merckx, Lazlo Somogyi, Winston Spriet, Esther Tamsma.

•

The Archives d'Architecture Moderne is financially supported by
the Brussels-Capital Region, the French Community Commission,
the French Community, the National Lottery, the limited company Cofinimmo.
*The activities of the Archives d'Architecture Moderne are organised within and with the support of the CIVA
(International Centre for Urban Development, Architecture and Landscape)*

front cover illustration:
*Facades of the Musical Instruments Museum, rue Montagne de la Cour.
Photograph Ph. De Gobert, 2000.*

After a long period during which art nouveau was ignored if not rejected, in the late sixties a movement gathered pace to award it the recognition it deserved. Interest gradually grew as exhibitions were organised and books published. Modern architecture began to be recognised as part of our national heritage. The Régie des Bâtiments was an active force within this movement.

In 1984 the Régie purchased the former Waucquez stores designed by Victor Horta and abandoned since 1970. This became home to the Belgian Comic Strip Centre. At the same time it acquired the Old England building which was to house the Musical Instruments Museum. Cooperation between the Régie des Bâtiments and private and public sector partners allowed these two buildings to be restored and converted in readiness for their new lease of life.

The Régie des Bâtiments plans to further pursue this policy by helping highlight new facets of our heritage whose importance has more recently been recognised, such as art deco. An excellent example is the Henry Le Bœuf concert hall at the Palais des Beaux-Arts which was restored to its former glory earlier this year, as well as the Prévoyance Sociale building in Anderlecht, the restoration of which is currently at the study stage. The Régie des Bâtiments is pleased to be able to contribute to the preservation and improvement of this exceptional heritage.

It is to make known to everyone this essential mission that it decided to support the production and publication by the Archives d'Architecture Moderne of this book entitled *Old England and the Musical Instruments Museum* which will make it possible to discover the work of Paul Saintenoy and the complexity of the works to restore and improve the Old England stores. In this way the Régie des Bâtiments is helping promote better knowledge of our urban heritage.

Leo Lauriks
Director-General
of the Régie des Bâtiments

Rik Daems
Minister of Telecommunications and
Enterprises and Public Participations

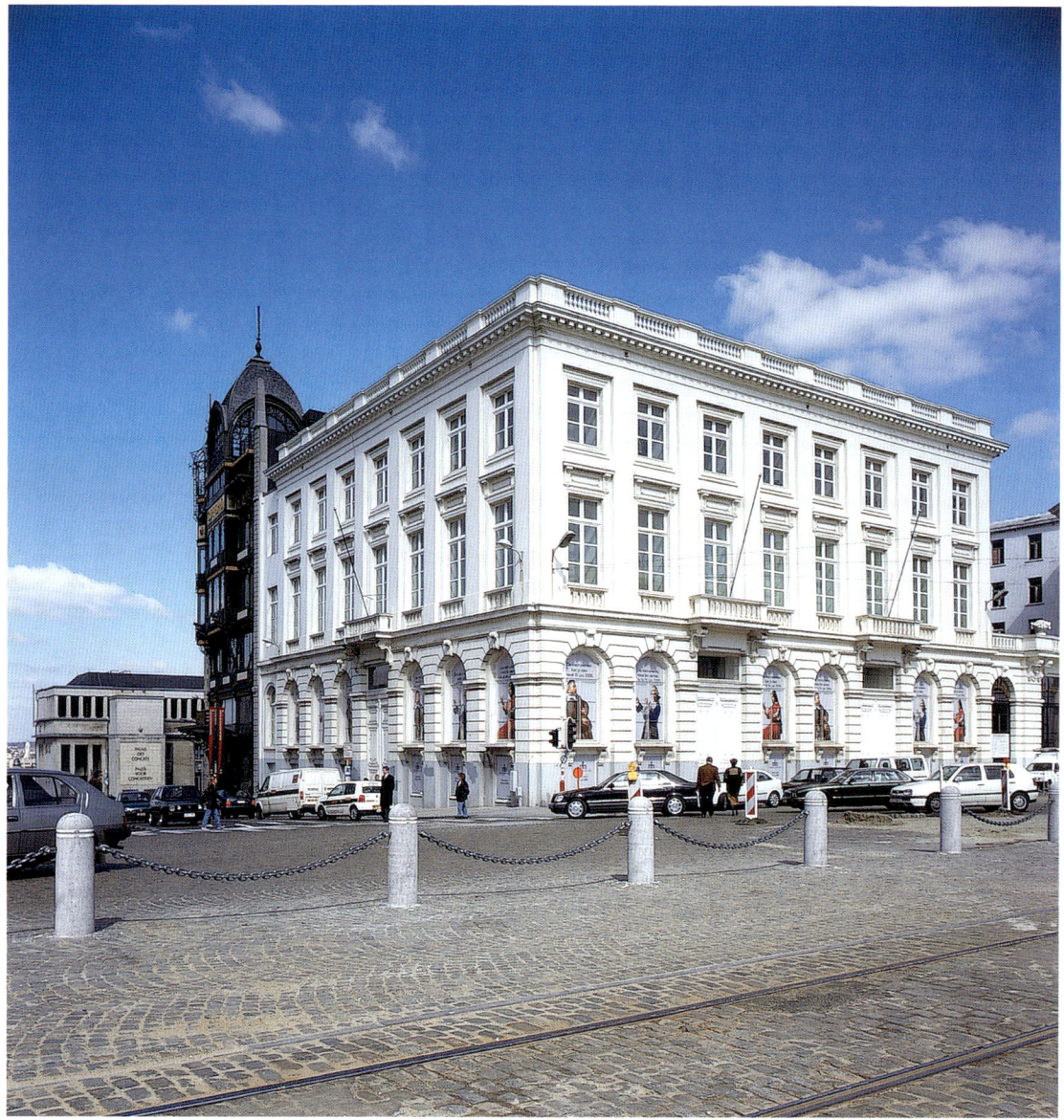

*The Musical Instruments Museum seen from the place Royale.
Photograph Ph. De Gobert, 2000.*

THE PLACE ROYALE AND THE MONTAGNE DE LA COUR

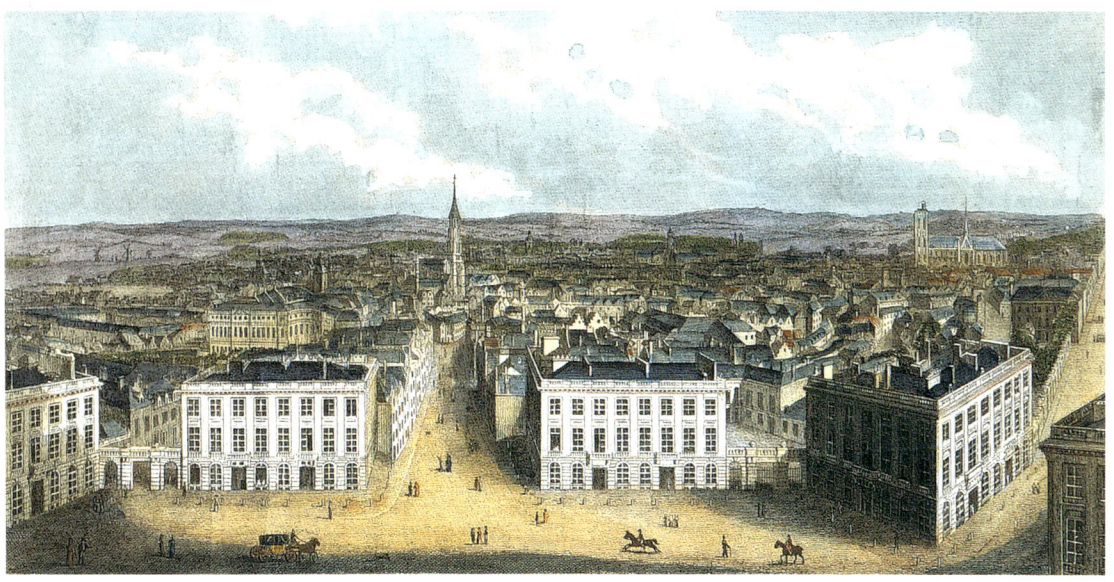

View of the place Royale towards the Montagne de la Cour, engraving published in London, 1834.

The creation of the royal square and park at the end of the XVIIIth century was probably the most radical urban transformation Brussels had ever seen. In 1769, the States of Brabant decided to erect a statue of Charles of Lorraine to celebrate the 25th anniversary of his appointment as governor general of the Austrian Low Countries. The project soon took on the aspect of a genuine royal square located at the highly symbolic site of the place des Bailles and the former Coudenberg Palace, the latter in a state of ruin after having been ravaged by fire in 1731. The project, drawn up with the cooperation of the Parisian architect Jean Benoît Vincent Barré and implemented by Barnabé Guimard, adopted a plan typical of the French royal square: Three median accesses – two roads and a concave portico to the future rue de la Régence – concentrate the perspectives on the central monument while the fourth side crowned with a pediment serves as a backdrop for the statue of the governor who faces the city. The regular facades provide an already neo-classical version of the model developed at the end of the XVIIth century by Jules Hardouin-Mansart: the ground-floor with strongly emphasised horizontal lines supports two floors with windows of different height framed by a colossal order of pilasters, reduced here to a simple projection of the wall surface.

THE PLACE ROYALE AND THE MONTAGNE DE LA COUR

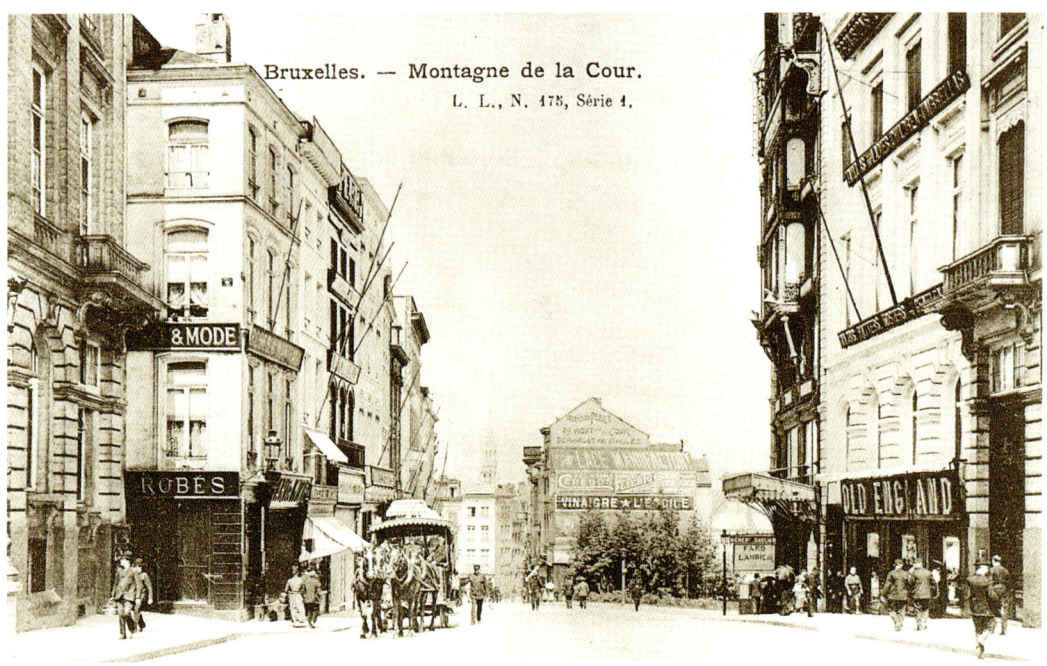

*The Montagne de la Cour and Old England stores seen from the place Royale.
Postcard, circa 1900.*

To guarantee the square a rigorous uniformity, the owners were issued with specifications and plans defining down to the very last detail the dimensions, motifs, materials and colours of the facades and roofs. Failure to respect these instructions would result in confiscation of the site and any materials found there. All new purchasers undertook to repaint the facades in the stipulated colour and at such time as the government may require them to do so.

The pavilion which a century later would house Old England, on the corner of the square and the rue Montagne de la Cour, was built in 1776-1777 on the property of the former Hoogstraeten town house for the comte de Spangen, chamberlain to Their Imperial and Royal Majesties, who also had built the adjoining courtyard and portico with three arches which encloses it. Like most of the buildings on the place Royale, in the XIXth century it was divided into several premises, partly of commercial use, which were to be occupied most notably by the Hôtel Britannique, the Taverne de la Régence and various private individuals. This rigorous place Royale dominated the traditional medieval town with its narrow winding streets and numerous blind alleys

THE PLACE ROYALE AND THE MONTAGNE DE LA COUR

*The Mont des Arts and rue Coudenberg. Postcard, circa 1910.
From right to left, Saintenoy's Old England building, the Delacre pharmacy,
the rear facade of the Delacre warehouses, the Ravenstein town house and the temporary shops on rue Coudenberg.*

and stairways leading to the Grand'Place. As the traditional link between uptown and downtown, from the early XIXth century the Montagne de la Cour district became one of the capital's centres of luxury commerce. English fashion had taken root here long before Old England, stimulated by the presence of many British families following the Battle of Waterloo. By the end of the century, the area was home or had been home at some time or other to La Librairie anglaise (the English Bookshop), Todd's English circulating library, the literary salon with the English bookshop Pratt & Barry, la Tabagie anglaise (the English Tobacconist), Carter's English Tavern, the British Tavern, the Prince of Wales, the English company Kodak, the English and American Perry shops, House of Forir, General Steam Navigation, Victor Balasse's House with its rubber objects and clothes, and Mr Alex, surgeon-dentist to the late Duke of Gloucester and supplier of *teeth of English composition...*[1]

The area's privileged situation also made it the subject of a bitter planning conflict between King Léopold II and the mayor of Brussels, Charles Buls. Pursuing his policy of monumental constructions, in 1880 the King charged his architect Alphonse Balat with the study for a vast

7

THE PLACE ROYALE AND THE MONTAGNE DE LA COUR

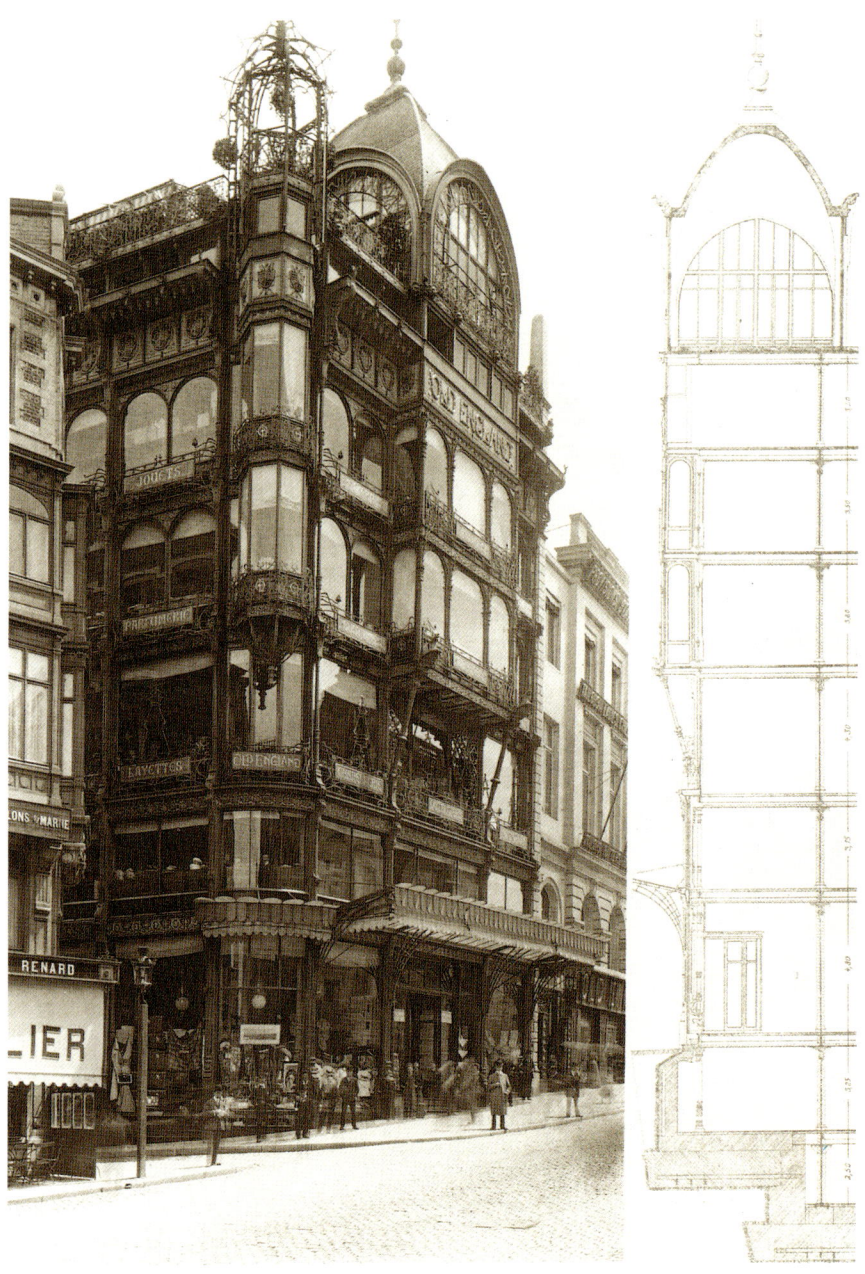

THE PLACE ROYALE AND THE MONTAGNE DE LA COUR

Opposite page:
The Old England stores.
Old photograph.
Die Architektur des XX.
Jahrhunderts, Berlin, 1906, pl. 202.

On the right and below:
Paul Saintenoy, restoration and conversion of the former Ravenstein town house, 3 rue Ravenstein, 1893.
• *Elevation of the facades giving onto the courtyard. Building permit application.*
• *Old photograph,*
L'Émulation, 1900, pl. 1.

Restoration and conversion of a XVIth century house, 1 rue Ravenstein, 1895. Old photograph,
L'Émulation, 1900, pl. 2.

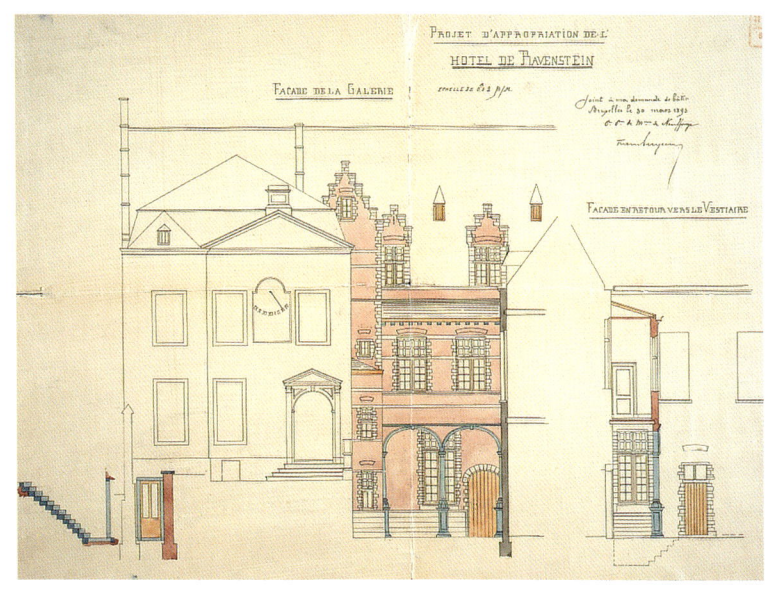

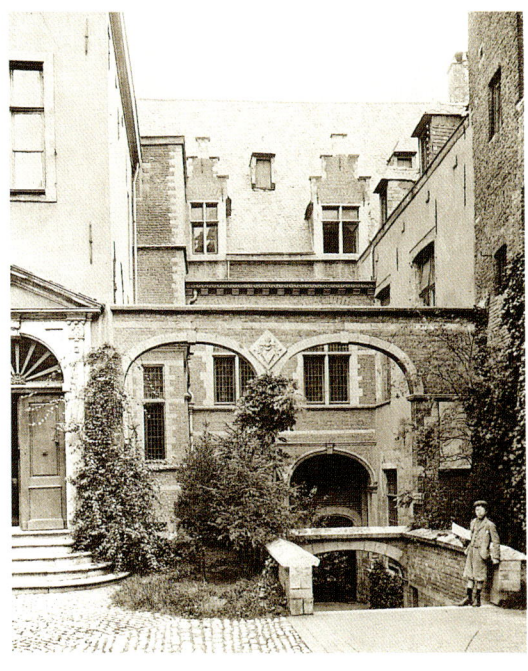

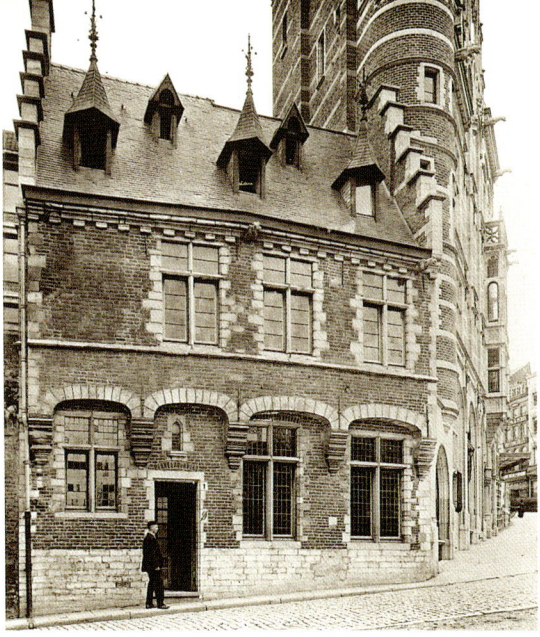

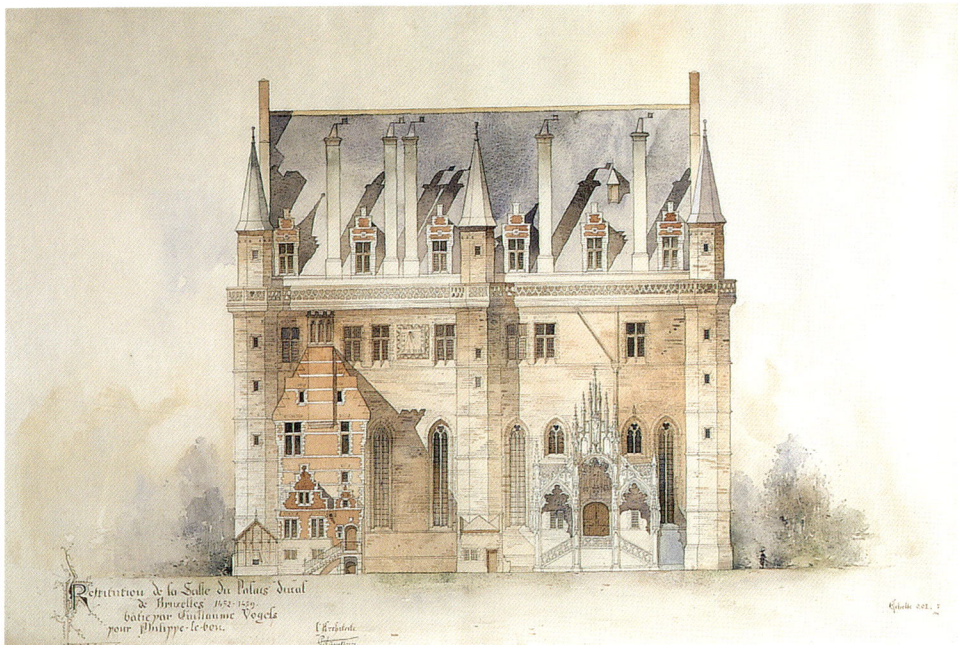

project which would bring together on Coudenberg hill some of the capital's principal cultural buildings, complementing the new Palais des beaux-arts (now the Royal Museums of Fine Art). The plan involved pulling down about a hundred houses and the construction of a winding road, rue Coudenberg, to soften the descent from the place Royale to the Cantersteen. An associated plan was submitted by Henri Maquet for a second much wider winding road, at the site of the present rue de Ravenstein and rue Cardinal Mercier. Appointed mayor in 1881, Buls was radically opposed to the King's "Mont des Arts" project. He wanted to maintain the area's commercial activity, one of the most prosperous in the capital, and conserve the picturesque urban fabric with its very remarkable old buildings, including the Ravenstein and Dupuich town houses, the latter also known as the Synagogue, and the remains of the Nassau town house. In 1893 he defended his ideas by publishing the small treatise entitled the *Esthétique des Villes* or "Aesthetics of Cities" which would quickly become an essential reference in any discussion of town planning at the turn of the century.

Despite protests from Buls, on 10 January 1895 a royal decree decided that the rue Coudenberg must be built. This was soon followed by eviction orders on about a hundred buildings and in 1897 the first demolitions. The mayor then attempted to preserve in full the magnificent

THE PLACE ROYALE AND THE MONTAGNE DE LA COUR

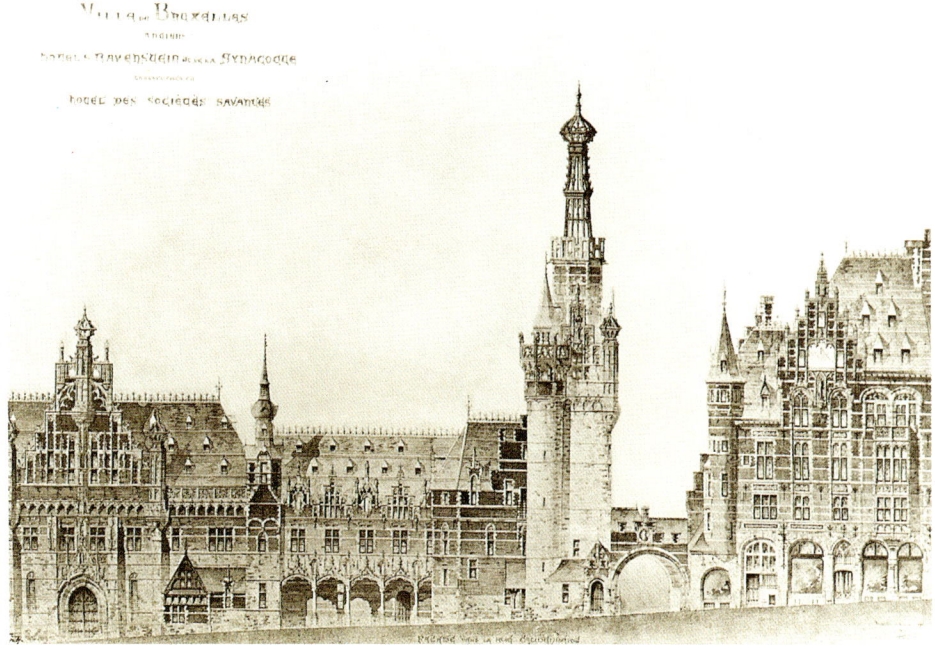

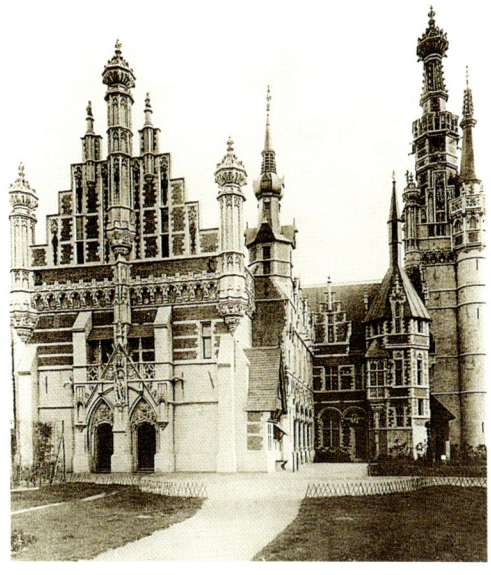

Opposite page:
Paul Saintenoy, reconstitution of the Magna Aula at the former Coudenberg Palace in Brussels, 1896.

Above:
Paul Saintenoy, project for the conversion of the Ravenstein and Dupuich town houses into a House of Learned Societies, 1896-1899.
Academy Architecture and Architectural Review, London, 1899, p. 110.
From right to left: the Delacre pharmacy, an archway leading to the rue Ravenstein, the project for a new facade for the Dupuich town house.

On the right:
Paul Saintenoy, Brussels City Hall at the 1897 Brussels International Exhibition.
L'Émulation, 1899, pl. 46.

THE PLACE ROYALE AND THE MONTAGNE DE LA COUR

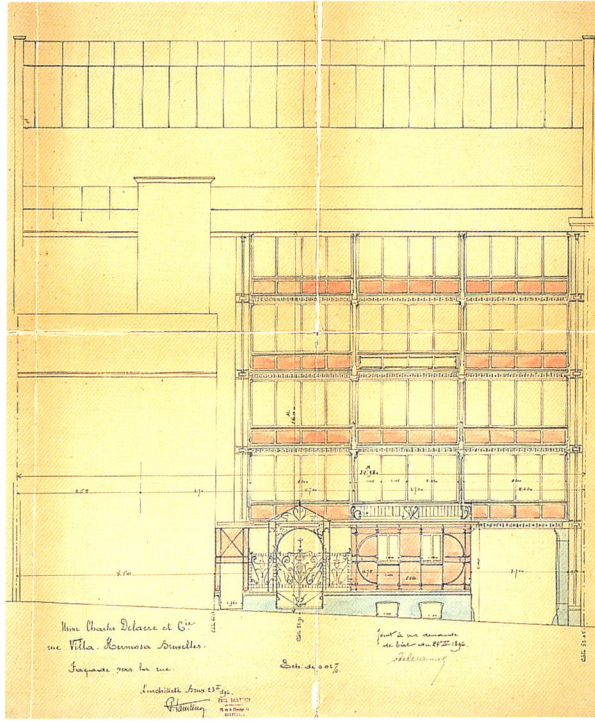

Paul Saintenoy, preliminary design for the facade of the warehouses for chemical products Ch. Delacre et Cie, 10-12 rue Villa Hermosa, 1896.

ensemble of XVth and XVIth century architecture represented by the Ravenstein and Dupuich town houses which faced one another on either side of the narrow rue Ravenstein. Failing to win the support of his city council, he resigned in 1899. Over subsequent years Léopold III purchased or arranged for the purchase of numerous sites or buildings with a view to realising the Mont des Arts. But just when the project seemed about to come to fruition, the presentation of the model in 1908 sparked a fierce public and parliamentary controversy which led to its indefinite postponement.

It was on this seemingly perpetual construction site, the subject of many false starts, that Paul Saintenoy erected the Old England building and produced a large part of his work between 1890 and 1910. His grandfather Jean-Pierre Cluysenaar and his father Gustave Saintenoy had already done much to shape the quarter's image: the former with the Madeleine market (1848), the Bortier gallery (1848) and the Conservatory of Music (1872-1876); the latter with the palace of the comte de Flandre which adjoined the place Royale (1866-1884).

In 1893, Paul Saintenoy was charged with a limited restoration of the former Ravenstein town house with a view to it being occupied by various learned societies. He concentrated mainly

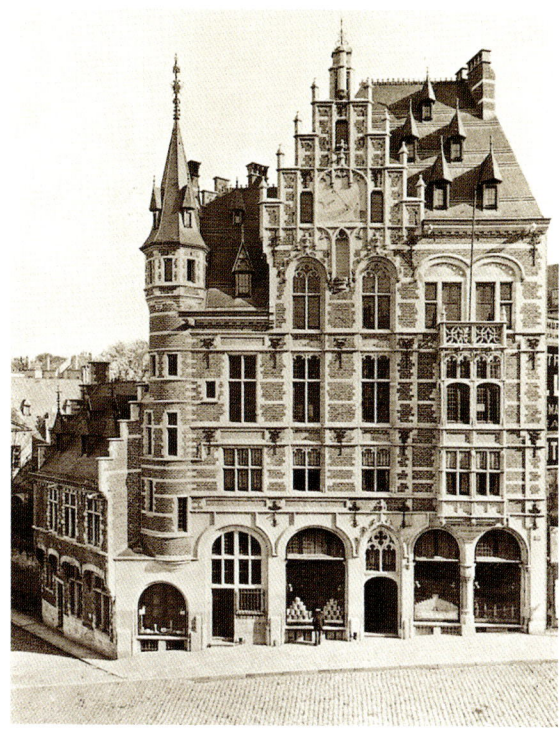

Paul Saintenoy, Delacre pharmacy,
62-66 rue Coudenberg, 1898. Old photograph.
Academy Architecture and Architectural Review,
London, 1900, p. 73.

on the interior courtyard.[2] Two years later he undertook the complete restoration of the small XVIth century house lying at the other end of the courtyard, the present 1 rue Ravenstein (1895).[3] In 1896-1897 he built, on a neighbouring plot, the depots for Delacre and Co. Chemicals products, at 10-12 rue Villa Hermosa, whose rationalist cast iron and steel facade already anticipates Old England.[4]

In an attempt to save the Dupuich town house, in 1896 Charles Buls asked Saintenoy to study a project to convert it into a House of Learned Societies, thereby complementing the use already being made of the Ravenstein town house.[5] The architect also proposed that the existing buildings on the rue Ravenstein and rue des Sols should be embellished, in the direction of the new rue Coudenberg, with a grand facade inspired by several Brussels buildings of the XVth and XVIth centuries.[6] The Brussels City Hall which Saintenoy built for the Brussels World Exhibition in 1897 was in reality a life-size model designed to win popular support for the mayor's ideas.[7] The construction of the Delacre pharmacy[8] in 1898 allowed Saintenoy to further expand his project: the rue Coudenberg would be given a coherent style with the pharmacy facade, the entrance to the rue

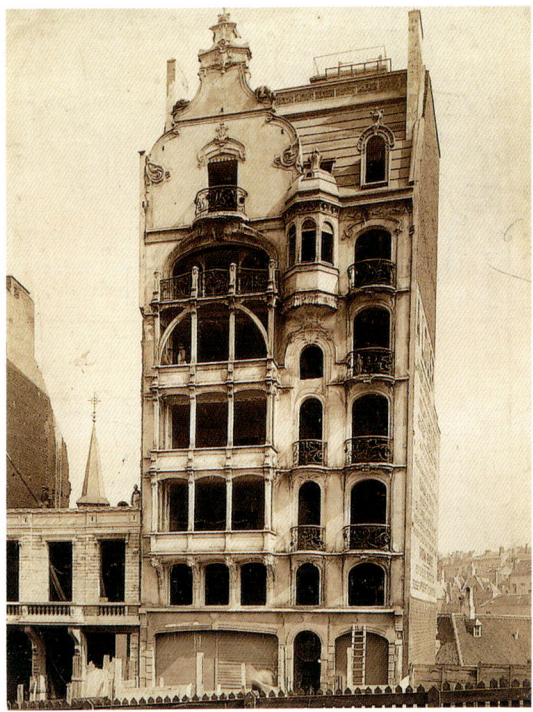 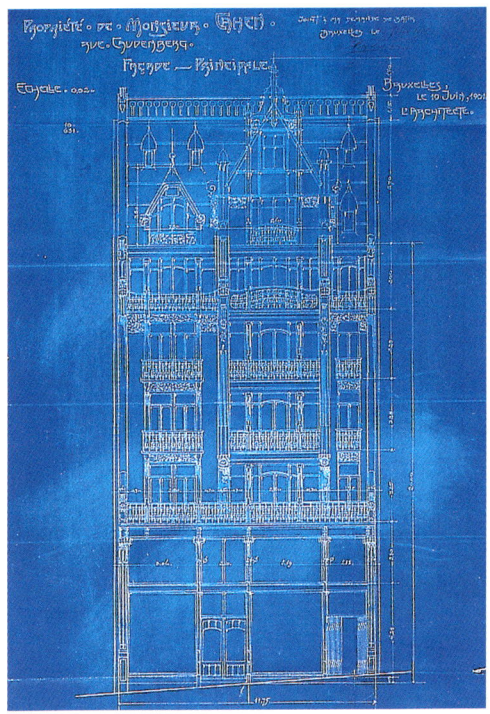

Paul Saintenoy, apartment house for J. Dubois-Petit, 46 rue Coudenberg, 1899 (destroyed). Old photograph.

Paul Saintenoy, apartment house for M. Cahen, 44 rue Coudenberg, 1901 (destroyed). Building permit application.

Ravenstein surmounted by a porch and the new facade of the Dupuich town house. That same year, he started work on building the spectacular metal structure of the Old England building (1898-1900). Continuing to work with avant-garde materials, a little lower down the rue Coudenberg he designed an apartment house for Jules Dubois-Petit, an exceptional art nouveau work which was considered to be Belgium's first building to be constructed exclusively in reinforced concrete (in 1899, destroyed)[9] and, on a neighbouring plot, the Cahen building also in reinforced concrete built according to the Hennebique system (1901, destroyed).[10]

The abandoning of the Mont des Arts project left the area devastated on the eve of the 1910 World Exhibition. This was hastily concealed by laying out an elegant cascade garden bordering the rue Coudenberg. It was again Saintenoy, active in the quarter for almost 20 years, who was charged with building some 20 shops there (1909-1910, destroyed) as a temporary solution, some of which

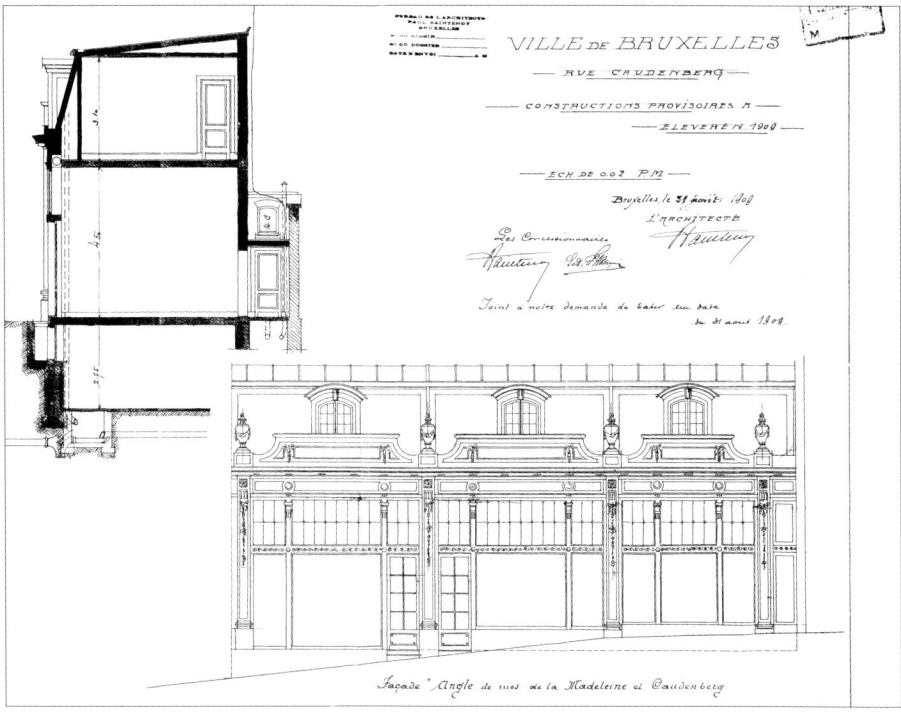

Paul Saintenoy, temporary shops, on the corner of the rue de la Madeleine and the rue Coudenberg, 1909-1910 (destroyed). Building permit application.

stood on the site of the Dubois-Petit building, the Cahen building and Dupuich town house, all purchased and then demolished at the instigation of Léopold II.[11]

Work on constructing the second road with its broad bend – now rue Ravenstein – began in around 1910. On the sites cleared between the rue des Colonies, the rue de la Chancellerie and the rue Montagne du Parc, Paul Saintenoy produced a final work, the huge Caisse Générale de Reports et Dépôts building, in a Beaux Arts style which would soon characterise most of the area's buildings (1910).[12]

The Montagne de la Cour long remained the focus of his thoughts. Taking the opportunity of enforced inactivity during the First World War he embarked on archival research which led him to his monumental study *Les Arts et les Artistes à la Cour de Bruxelles* (1932-1935) in which he charts the history of the Coudenberg from the XIIth century until the reign of Albert I.

THE OLD ENGLAND STORES

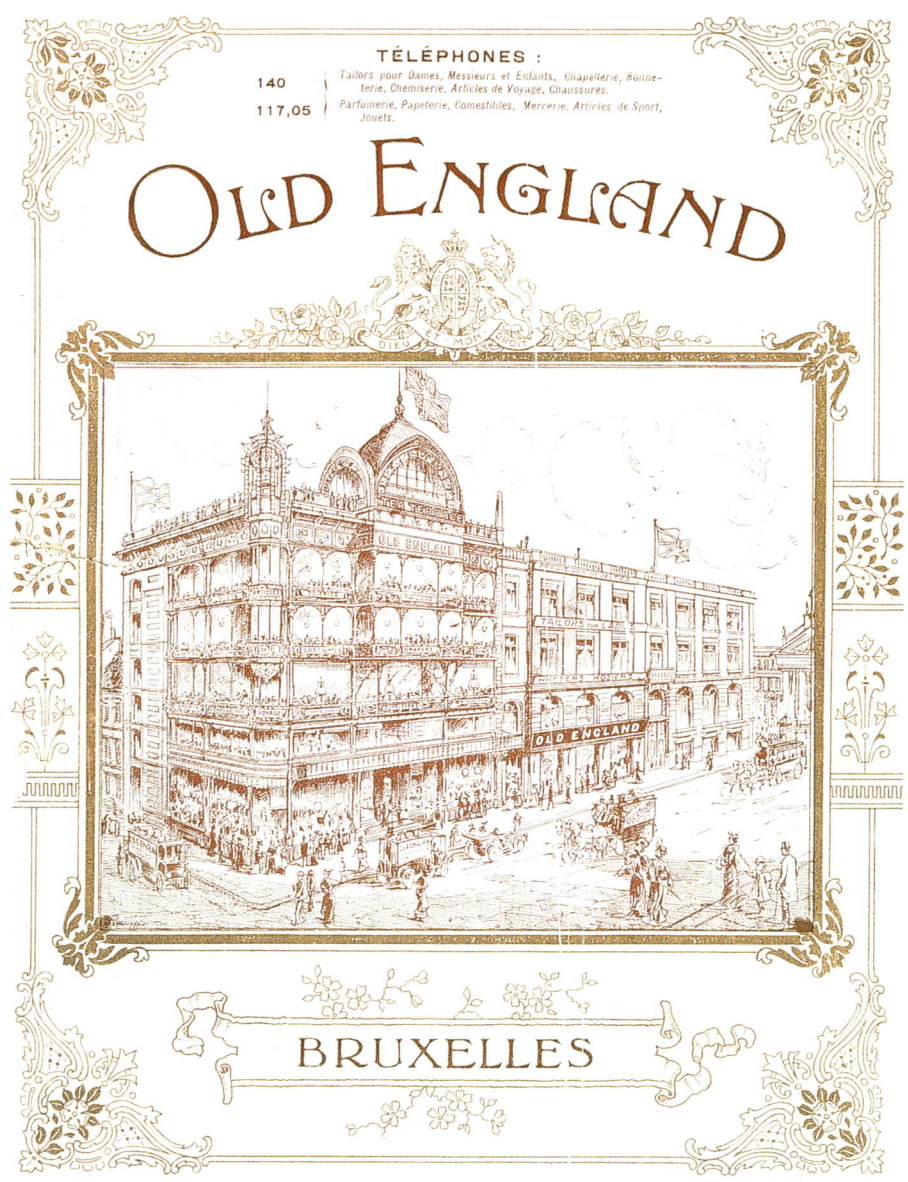

Cover of the Old England tea room menu, circa 1900.

The "Old England" sign appeared for the first time in Brussels in the spring of 1886, on a shop front at 94 rue Montagne de la Cour. This new store, in a part of the town house originally built for the comte de Spangen in 1776, offered the prosperous clientele of the area English fashion articles for men, women and children as well as a range of food specialities.[13]

The Old England stores were well established in Europe – Paris, Rome, Bordeaux, Biarritz, Pau, Trouville, Geneva – when James Reid (1821-1888), a merchant of Scottish origin living in Paris, founded the Brussels business. Management was entrusted to three partners, Edmond Keon, Josiah Lisle and Victor Malguy, who founded "Keon, Lisle, Malguy et Cie" on 30 April 1886, the sleeping partner James Reid having provided the start-up capital of 187,500 francs and the name "Old England" to which he retained exclusive ownership rights.[14]

It was the beginning of a success story. Over subsequent decades the Brussels store was repeatedly extended until it came to occupy the whole of the plot between the place Royale and the rue Villa Hermosa. The first and most spectacular extension was in 1898-1899 with the construction of the metal building on the corner of the rue Montagne de la Cour and the rue Villa Hermosa. This new building, built at the initiative of Josse Édouard Goffin who acquired the plots neighbouring the shop in July 1897, to which he added a site he already owned on rue Villa Hermosa,[15] was designed by the architects Paul Saintenoy (1862-1952) and Jules De Becker (1847-1906).

Thus extended, the Old England house became a genuine department store for new articles, its many departments and several floors offering a vast choice of products. Several floors were devoted to clothing – for ladies, gentlemen, boys, girls and toddlers – the other floors being given over to food, perfume, haberdashery, stationery, clocks and watches, toys, travel, sports and garden items. A lift took customers up to the Tea Terrace and *the most beautiful panorama of Brussels and its surroundings*. The sales methods were in line with the new commerce. Goods were supplied on receipt of full payment only and without discount. A dispatch department organised home delivery of orders, with catalogues and samples sent out on request.

By June 1905 Old England was already considering further extensions. The idea was to expand the store towards the place Royale by incorporating another section of the Spangen town house at 96 rue Montagne de la Cour – including the former courtyards and stables – belonging to Josse Édouard Goffin and his mother. The conversion plans were submitted to the Saintenoy bureau which also added an elegant new area to the tea room.[16] At the same time, on 3 July 1905, the Old England limited company was founded with a capital of 800,000 francs, with the purpose of *operating the house of commerce at 92, 94 and 96 Montagne de la Cour and its subsidiary in Ostend,*

THE OLD ENGLAND STORES

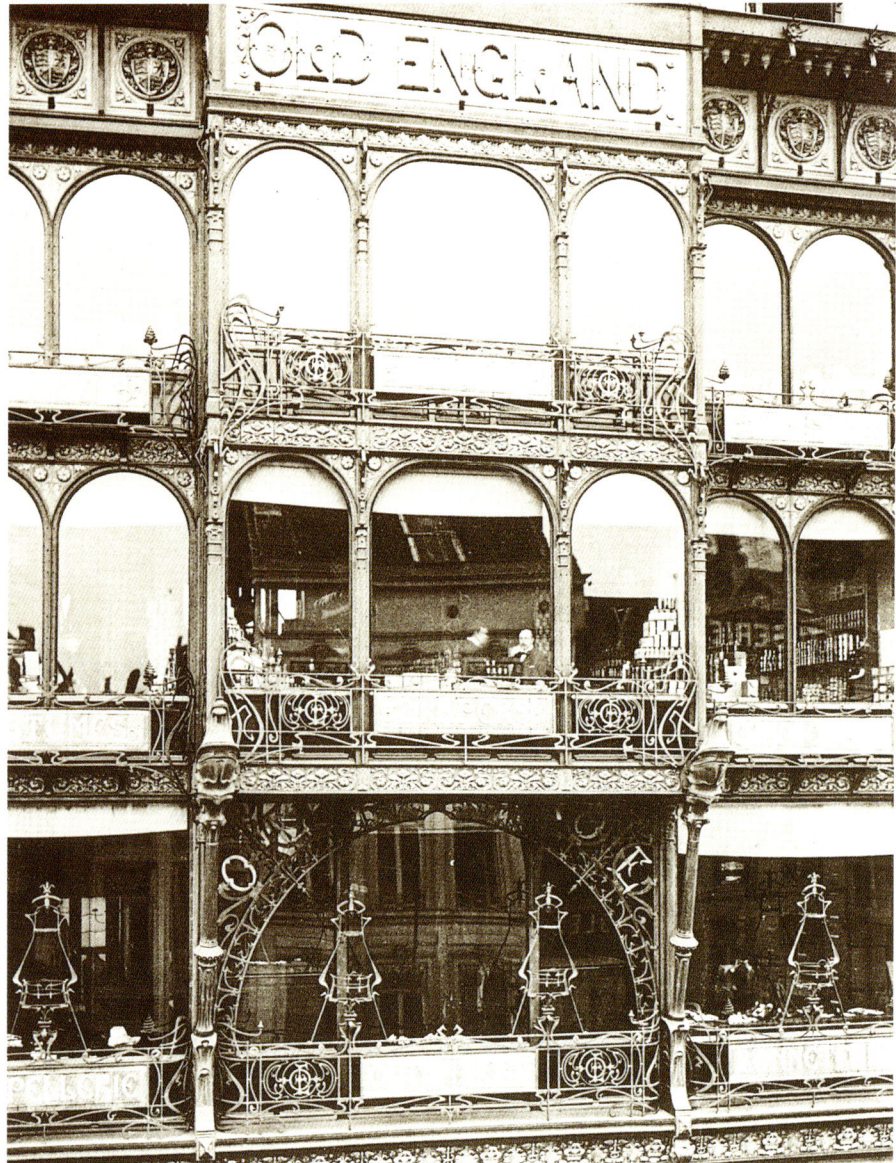

Detail of the Saintenoy building facade. Photograph circa 1900.
Ferronneries de Style Moderne, Paris, undated, vol. 1, pl. II.

THE OLD ENGLAND STORES

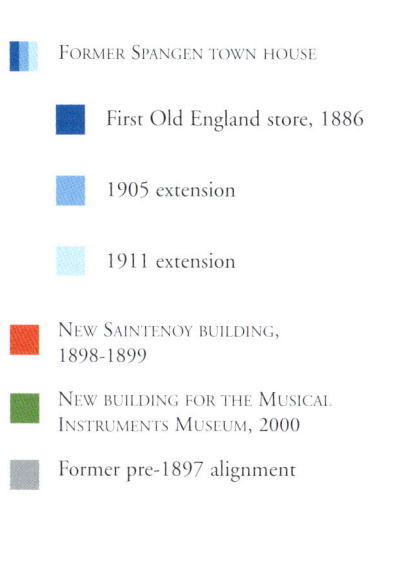

- Former Spangen town house
- First Old England store, 1886
- 1905 extension
- 1911 extension
- New Saintenoy building, 1898-1899
- New building for the Musical Instruments Museum, 2000
- Former pre-1897 alignment

Plan of the various buildings which constitute the present Musical Instruments Museum.

at 27 and 29 rue Rampe de Flandre.[17] The Ostend house, opened in 1897 at the same time as another shop in Liège,[18] was seasonal only and closed in 1935.

Four years after the limited company was founded it launched a genuine wave of acquisitions. In 1909 it bought the "buildings and courtyards" occupied by the Taverne de la Régence (or Taverne Strobbe) at nos 13 and 14 place Royale;[19] in 1911, the building of the first shop at 94 rue Montagne de la Cour[20] followed by the "Saintenoy" building on the corner of the rue Villa Hermosa, and finally the building on the corner of the rue Montagne de la Cour and place Royale.[21]

In 1913, the Old England directors submitted an application to convert all of their new acquisitions: *The two town houses facing the Place Royale, and set at a reentrant angle to the Cour des Comptes, will be entirely demolished with the exception of the Place Royale facade, which will be repaired. The thus converted stores will have four facades, on the rue Villa Hermosa and Montagne de la Cour, the Place Royale and the Cour des Comptes... The stanchions, beams, floors, roof and stairs for the*

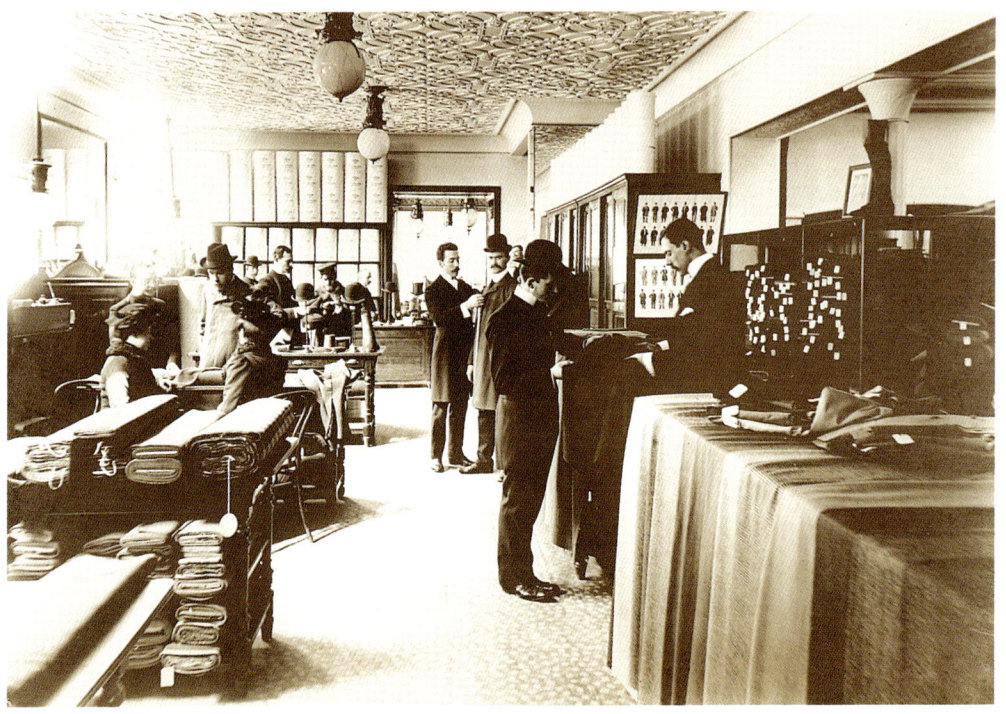

new premises will be constructed in reinforced concrete. The Uccle architect Gustave Hubrecht created a luxury interior in marble, stucco and mahogany more suited to the function of a department store.

An application was submitted at the same time to the Minister of Public Works *to obtain permission to build a monumental facade facing the Cour des Comptes at the site of the present facade which is in a poor state of repair and without any architectural interest.*[22] This facade, also due to Hubrecht, was the same elevation as the buildings on the place Royale but with an exposed stone facing rather than coated brickwork. That same year a new project to expand the tea room in the direction of the place Royale was rejected by the city authorities which deemed the scale to be too imposing. It was finally built in 1915, on the rue Villa Hermosa side and according to plans drawn up by Hubrecht[23] who also produced other minor works between 1922 and 1928.

The Old England extensions were not confined to the plot between rue Villa Hermosa and the place Royale. In 1914, the former Renard café on the corner of the rue Coudenberg,

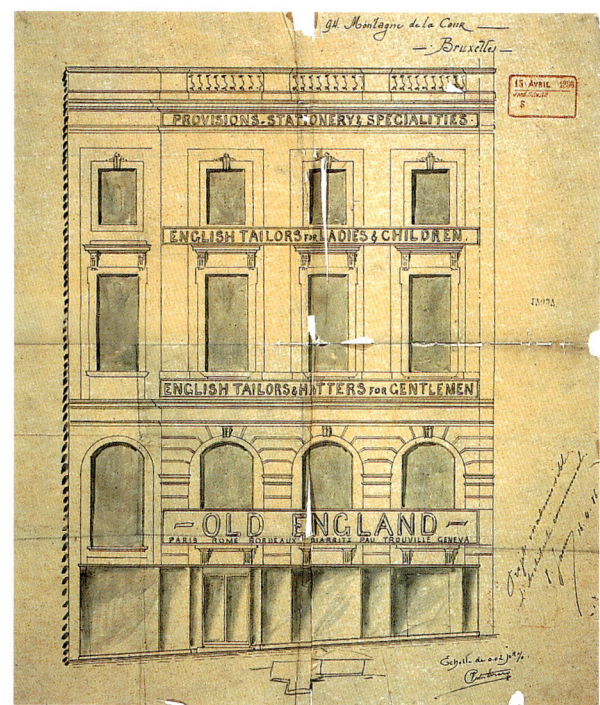

Opposite page:
The gentlemen's clothing department in the Guimard building. Photograph É. Mercier circa 1900.

On the right:
Project for the transformation of the windows for the first Old England store, 94 rue Montagne de la Cour, 1886.

already partially occupied by garment manufacturers, was converted into a shop by Hubrecht.[24] In 1925, the Delacre warehouses at 10-12 rue Villa Hermosa were converted into workshops.[25]

In 1938, to facilitate the maintenance and conceal a style which had become antiquated, Saintenoy's metal facade was stripped of *all the ornaments in cast iron and iron that it will be possible to remove* and repainted in white in keeping with the buildings on the place Royale.[26] In 1956 the corner turret was dismantled, as it seemed to be in danger of collapsing, under the responsibility of the architect Jean Hendrickx van den Bosch.[27]

The need for Old England to adapt its store to the new laws on protection against fire following a catastrophic fire at the Innovation department store in 1967, and the progressive abandoning of the district by the luxury clientele caused the company to forsake the premises and set up its clothing department on avenue Louise. The famous tea room finally closed and the building was sold in 1973.

THE OLD ENGLAND STORES

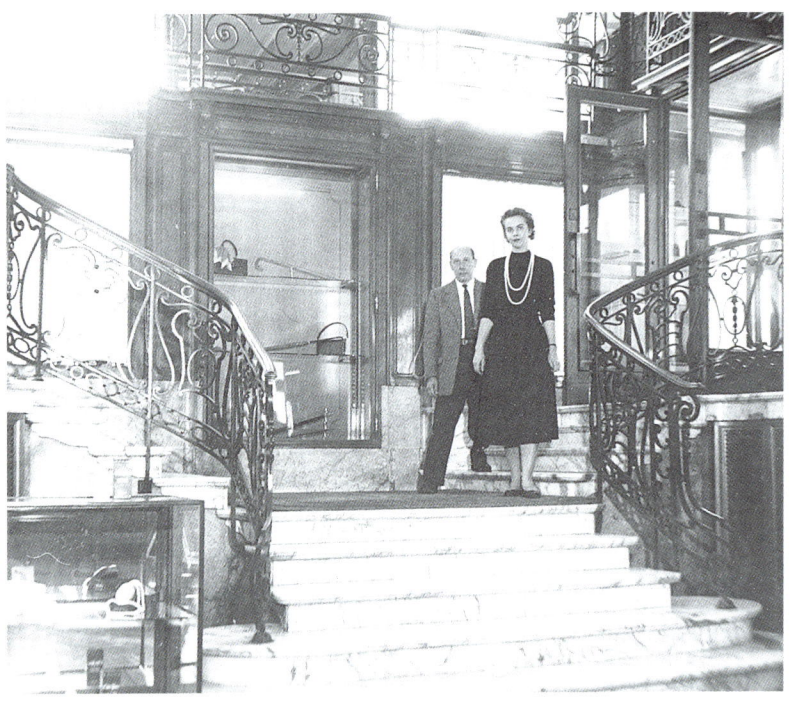

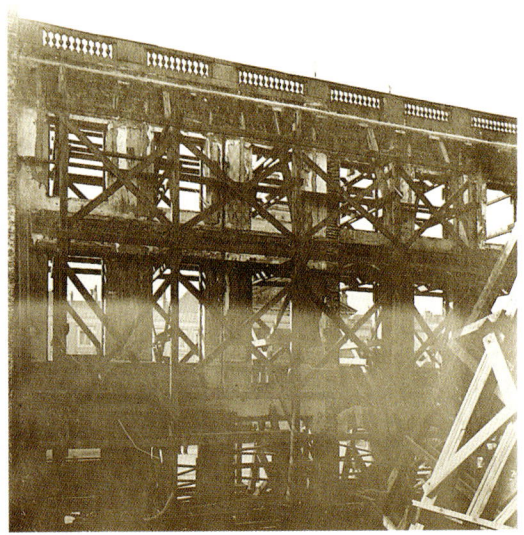

Above and left:
Gustave Hubrecht, the marble staircase with showcases at the entrance to the Guimard building, 13-14 place Royale, created in around 1913. Photograph circa 1950.

Gustave Hubrecht, interior conversion of the Guimard building for the Old England stores, place Royale facade seen from inside the building, 1913.

Opposite page:
Detail of the Saintenoy building facade on the rue Villa Hermosa, after restoration. Photograph Ph. De Gobert, 2000.

THE OLD ENGLAND STORES

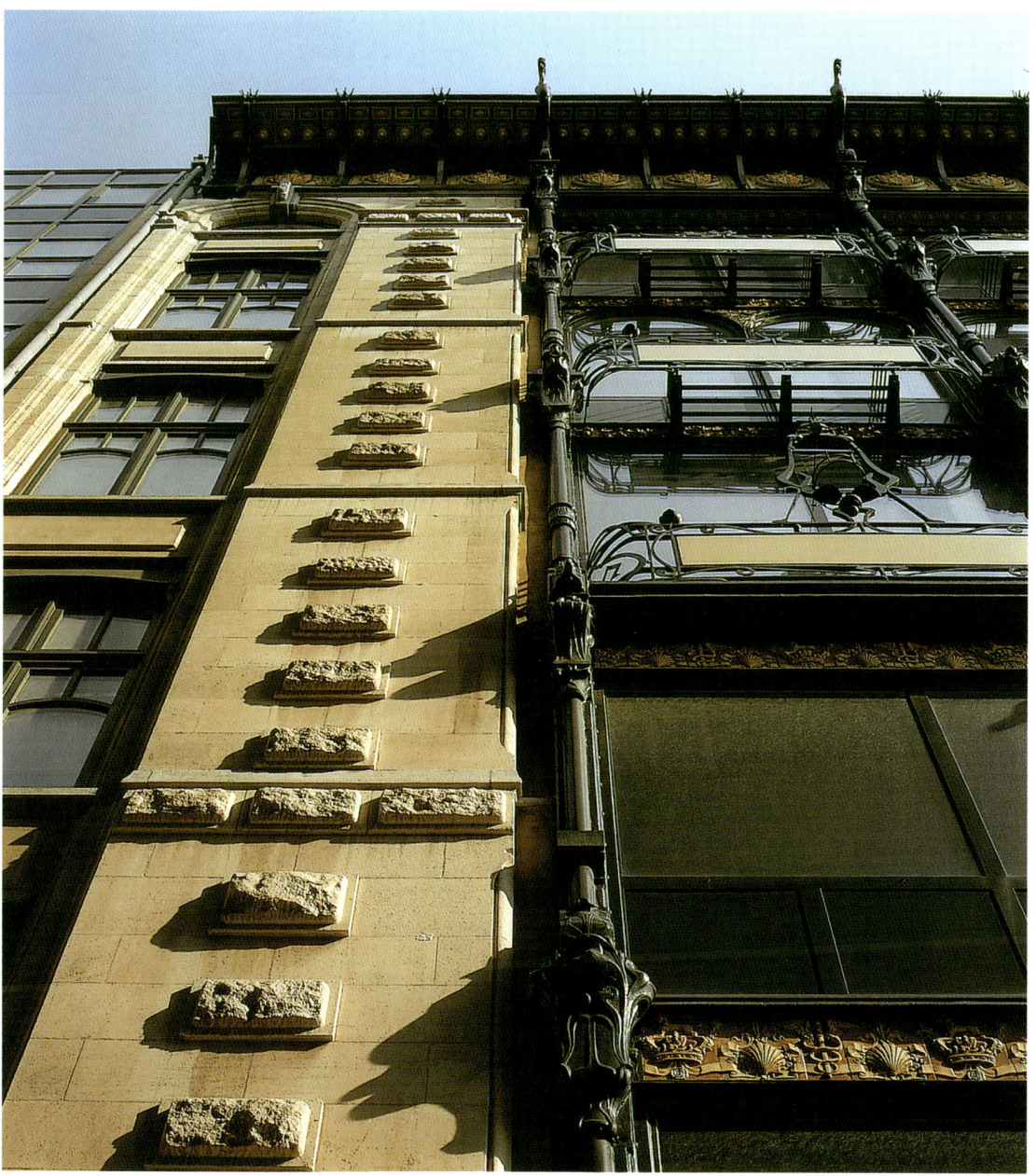

— 23 —

THE SAINTENOY BUILDING

Paul Saintenoy occupies a very original place in the panorama of art nouveau in Belgium. Close in his thinking to the ideas of Charles Buls, he no doubt awarded less importance to creating a personal style than to a careful analysis of the programme and urban environment into which a project was destined to integrate. Passionately interested in the history of architecture and archaeology, subjects on which he published many works, he tried to reconcile the conservation and improvement of the remnants of the old town with a modern architecture based on the forms and techniques of his age.

This complex approach seems to have won no more than limited support in the circles which gave birth to art nouveau in Brussels. While the work of Paul Hankar was inspired by his close relations with a circle of artists to whom he would owe some of his principal commissions, while Victor Horta was supported by a group of progressive intellectuals and industrialists centred around Brussels University, and while Ernest Blérot and Gustave Strauven responded to the demands of an upper middle class seeking to display its modern convictions, Saintenoy seemed to be an isolated figure despite the commissions he received from the occasional enlightened figure such as Charles Buls, Josse Goffin, Jules Dubois-Petit or Léon Losseau. He produced about ten works which can be described as art nouveau, constituting a series of experiments in modernity adopting sometimes very different forms and materials. Saintenoy also believed in the autonomy of aesthetics. The technical and formal design of his works are generally – and particularly in the Old England building – two distinct and complementary moments which he does not attempt to merge within an illusory unity. Although the almost simultaneous construction of Old England and the Gothico-Renaissance building of the Delacre pharmacy may seem strange, they in fact bear witness to a coherent reflection on the relationships between history, style and technique.

At the end of his life Saintenoy spoke of how his maternal grandfather, the architect Jean-Pierre Cluysenaar (1811-1880), introduced him in his adolescence to the rationalism of the *Entretiens sur l'architecture* by Viollet-le-Duc which would become his first bedside book.[28] From the first half of the XIXth century, Cluysenaar had been interested in the possibilities offered by the use of metal in many original designs, such as the Saint-Hubert galleries (1846-1847) and the Madeleine market in Brussels (1848), and the initial plans for the impressive metal church at Argenteuil (1850-1862, destroyed). During his studies at the Antwerp Academy, the young Saintenoy was above all impressed by his studies under Joseph Schadde (1818-1894), who came to international attention for the remarkable metal structure of medieval inspiration used for the reconstruction of the Bourse (1872).[29]

The 1889 Paris World Exhibition, at which the use of metal produced feats never before seen – rising to 300 metres at the Eiffel Tower and spanning 115 metres at the Galerie des Machines –,

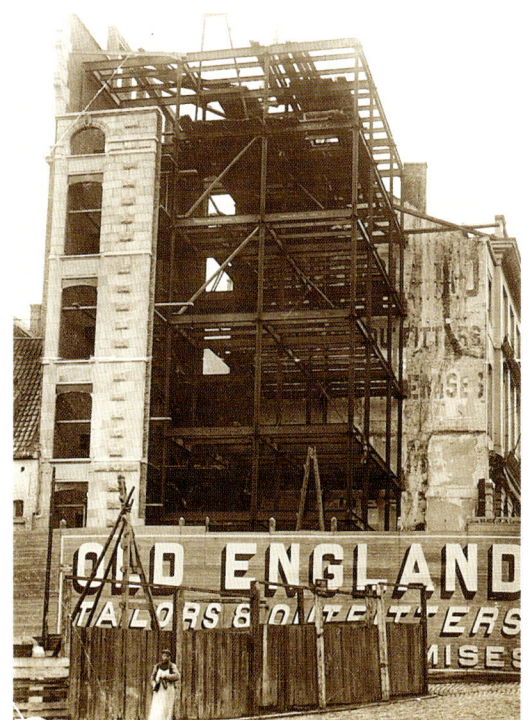 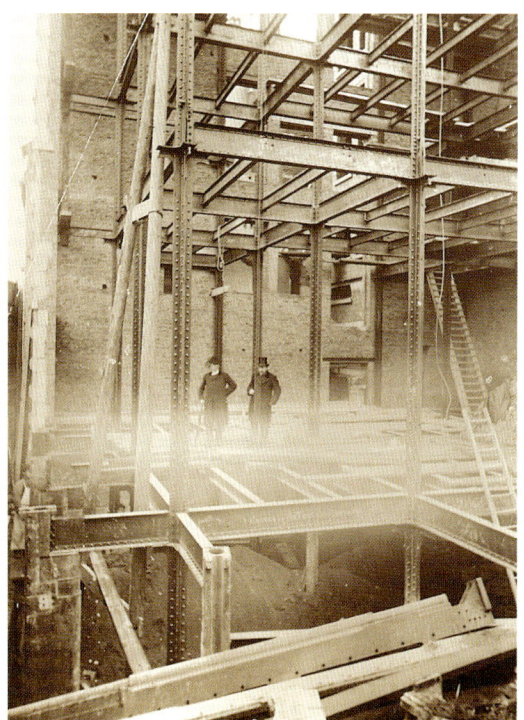

The Saintenoy building under construction. Site photographs, 31 December 1898.

was the occasion for Saintenoy to publish a first article on metal architecture, in which he reveals a conflict between an interest in the development of techniques and a hesitation in the face of the radical renewal of the architectural codes it implies. He covers a number of subjects which directly relate to Old England: the decorative use of rivets and punched metal sheet, the need to give cast iron or assembled metal sheet columns new architectural forms freed from the models of the past, the role of polychromy combining metal and the warm colours of ceramics.[30] The next year he returned in another article to his thoughts on relations between technique and aesthetics: *It is to be envisaged, however, that with the – still tentative – metal constructions, when we no longer simply cover a given space as one resolves an algebraic formula, when a sentiment of art causes us to no longer reveal the skeleton of the construction, but to better highlight its organs by a rational decoration of the internal surfaces of the frame, either by infilling with ceramics or giving a metal basis – as proposed by Viollet-le-Duc more than 20 years ago – a genuinely new architecture will be born.*[31] His notes on his travels in England,

THE SAINTENOY BUILDING

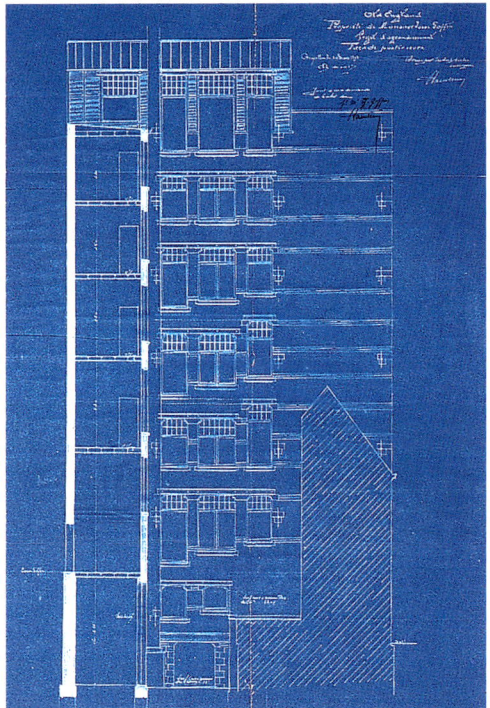

Building permit plan for the rear facade of the Saintenoy building, 1898.

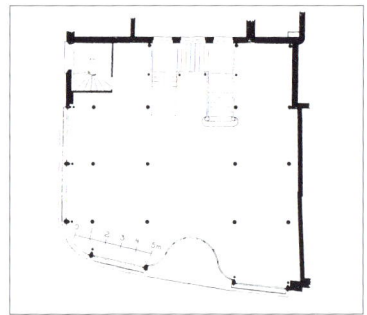

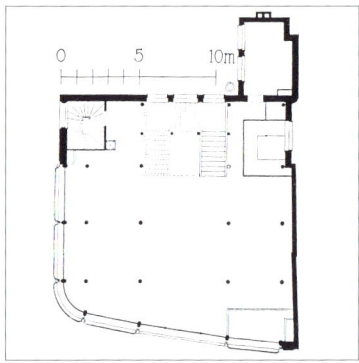

Ground floor and first floor plans.
Die Architektur des XX. Jahrhunderts, Berlin, 1906, pl. 202.

published between 1891 and 1893, ended with an enthusiastic appeal for a new metal architecture: *The iron girder will make its appearance and who knows? It will perhaps not prove itself too intractable to adopt an artistic form. Already the Paris World Exhibition, in 1889, had shown us this by yielding to all the caprices of the artist in an excellent marriage with ceramics. That is the future!*[32]

The warehouses of Ch. Delacre et Cie chemicals, built in 1896-1897 at 10-12 rue Villa Hermosa, are a kind of preliminary exercise which allowed Saintenoy to experiment in the formal and constructive qualities of cast iron and steel in a vocabulary already marked by art nouveau, just a few dozen metres from the future Old England. Exposed metal structures had been commonly used for the interior of department stores since the 1870s and in many buildings the masonry concealed a metal frame which had become entirely autonomous.

On and adjacent to the place Royale, the architectonic regulations which had preserved the unity of the facades since the XVIIIth century prevented any external changes to highlight the shops.

THE SAINTENOY BUILDING

When Old England opened in 1886, the City refused a project to modify the displays which would detract from the primitive design of the windows.[33] The new building erected at the corner of the rue Villa Hormosa, however, provided the opportunity for a spectacular enterprise: that of creating in one of the capital's most fashionable quarters and no doubt for the first time in Belgium a large commercial edifice entirely in metal.

In a perhaps deliberate word-play, Old England gave itself an uncompromisingly modern image with an original cast iron and steel structure, an innovative style, a boldness of colour which contrasted sharply with its environment, modernity in the techniques and materials used (reinforced concrete, glass brick, vitrified clay), as well as a lift and electric lighting, heating and ventilation. As the new focal point for the quarter, the building fully adhered to the definition which Frantz Jourdain gave a few years later to La Samaritaine in Paris: *one should not forget the role of temptress which a department store must play. Just as the pretty passer-by can add to her natural grace and her charms bestowed by nature with the attractions of make-up and the provocative note of a dress in shimmering colours, so a department store of our age should not fear being eye-catching: on the contrary, it is perfectly fitting for it to catch the eye and entice the client.*[34]

As a demonstration of the technical and aesthetic possibilities of a metal construction, the building certainly benefited from the support of the site's owner, Josse Édouard Goffin, mayor of Berchem-Sainte-Agathe but also director of and principal shareholder in the Forges de Clabecq which supplied the various metal components.[35] The theme of metal architecture impassioned the pioneers of art nouveau at the time. In 1894 Paul Hankar had designed his famous tower project for the 1987 Brussels Exhibition. The next year, together with Paul Jaspar, he designed a project for a theatre with an exposed metal frame in Liège. For the Congo exhibition in Tervueren, in 1897, Victor Horta conceived a removable structure of iron, tiles and earthenware. Horta's Maison du Peuple in the course of construction (1896-1899) was also an essential reference which no doubt stimulated Saintenoy to adopt a bold approach.

The Old England plans were produced by Saintenoy with the cooperation of Jules De Becker, former mayor of Koekelberg and architect specialising in surveys who had already worked for Goffin.[36] The application for a building permit was submitted by Goffin on 29 January 1898.[37]

Mayor Charles Buls, who had found in Saintenoy a valuable ally in his defence of the Montagne de la Cour district, informed his administration that same day that *The architects submitted to me the project for a facade with a central gable and I approved it from an aesthetic point of view.* Thanks to the benevolence of Buls, the rue Villa Hermosa facade of this truly artistic construction was also able to rise to more than double the regulation height. The calculations for the metal structure were entrusted to the engineer Emile Wyhowski and the construction was built by the Jean Vandeuren enterprise of rue G. Stocq in Ixelles.

THE SAINTENOY BUILDING

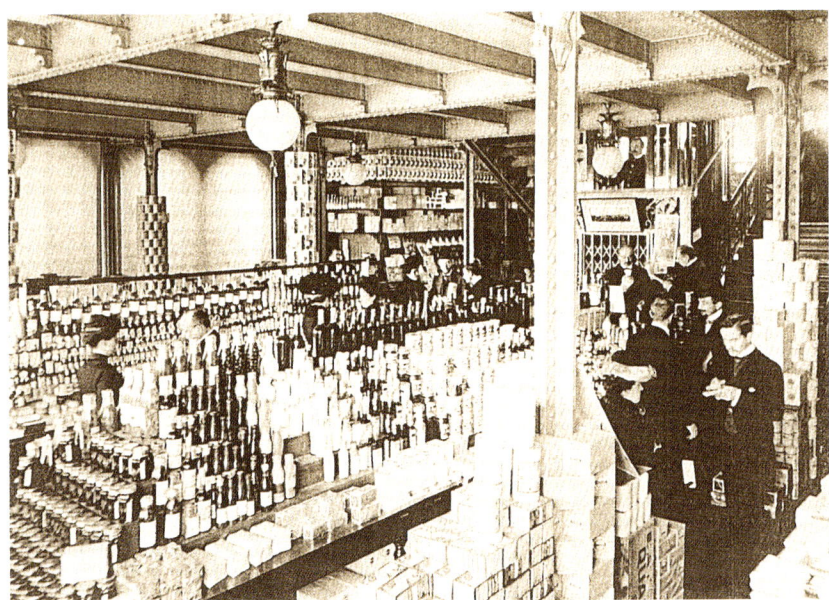

The food department in the Saintenoy building. Photograph circa 1900.

Work proceeded quickly. A series of photographs taken on 31 December 1898 show the metal frame almost fully erected, with the exception of the facades independent of the interior structure. The large awning which protected the entrance was the subject of a separate request for a building permit on 9 March 1899. Old England was, however, refused permission to place a second awning along the former neo-classical building on the corner of the place Royale. The building was inaugurated on Monday 26 March 1900.[38]

The new street line of the rue Montagne de la Cour as decreed by the City reduced the plot acquired by Goffin by almost a quarter, leaving just a limited area of approximately 230 square metres, plus the small rear courtyard.[39] Saintenoy's simple and rational project was for a tall building whose free plan allowed the counters to be rearranged at will with a succession of totally open floors linked by the stairwell with lift on the rear facade. On the seven floors from the basement to the roof terrace the building presented an orthogonal frame of steel pillars and girders produced by the Braine-le-Comte factory from riveted angle sections and sheet. On each floor the girders supported a slab of concrete reinforced with wire mesh. The traditional brick and stone masonry was essentially limited to the two party walls, the rear facade and the final bay of the rue Villa Hermosa where there were service stairs, which have now disappeared.

THE SAINTENOY BUILDING

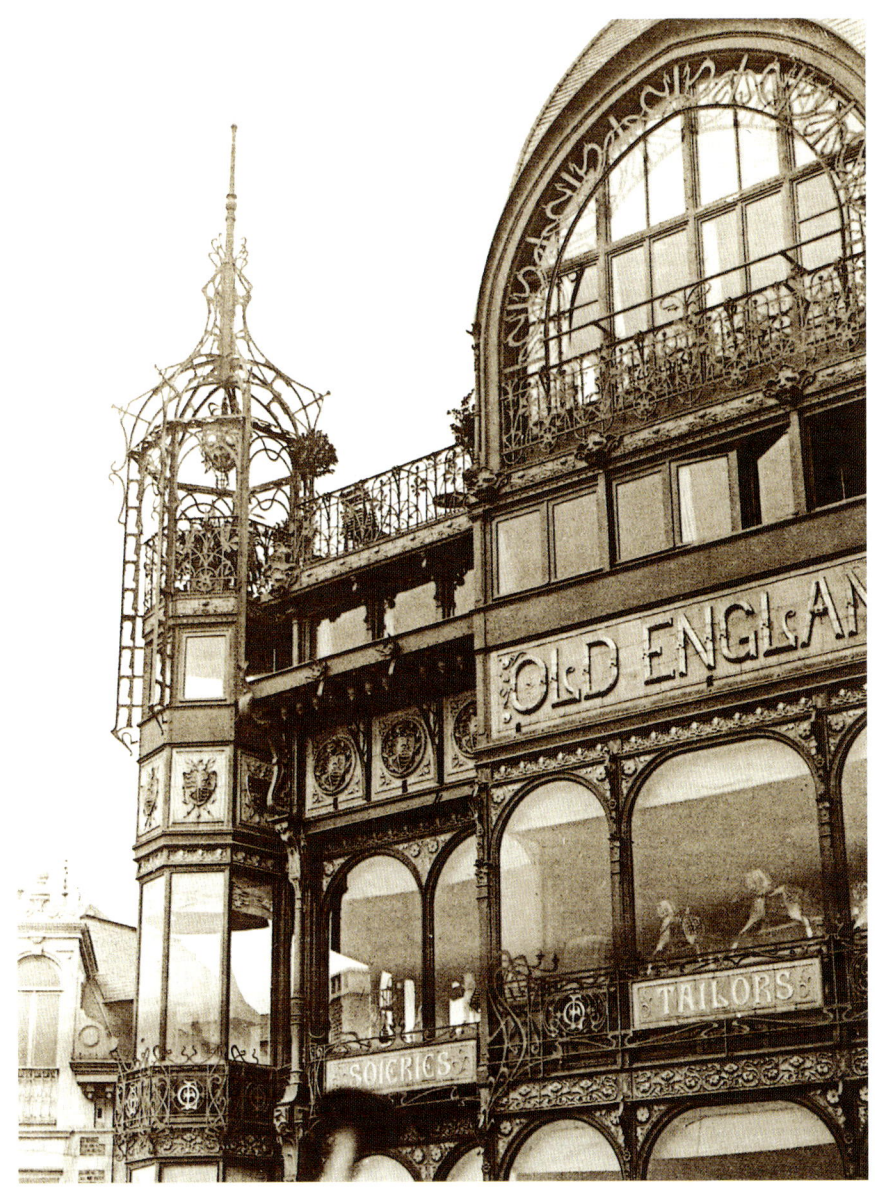

Detail of the Saintenoy building facade. Photograph circa 1900.
Ferronneries de Style Moderne, Paris, undated, vol. 1, pl. II.

THE SAINTENOY BUILDING

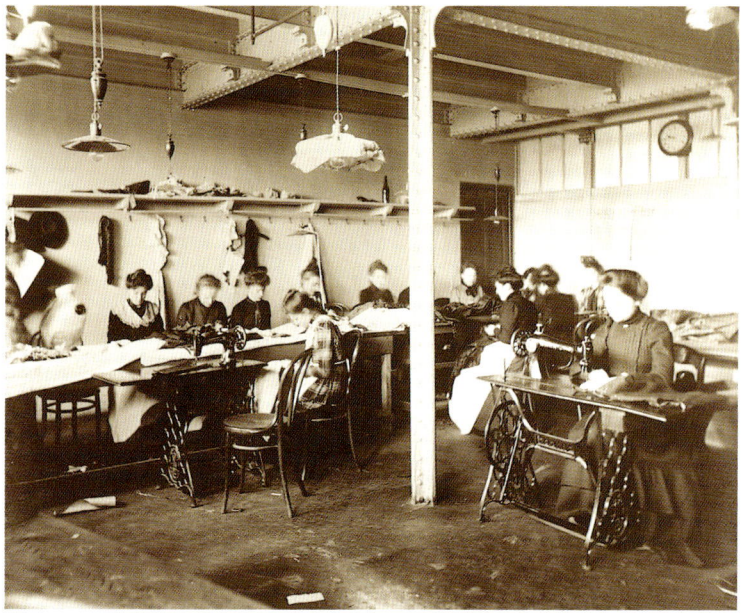

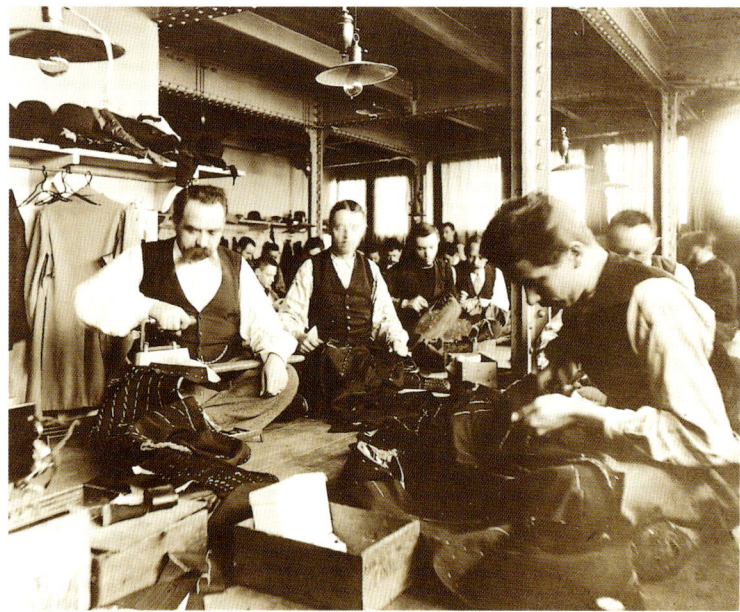

The sewing rooms on the fifth floor of the Saintenoy building. Photographs É. Mercier circa 1900.

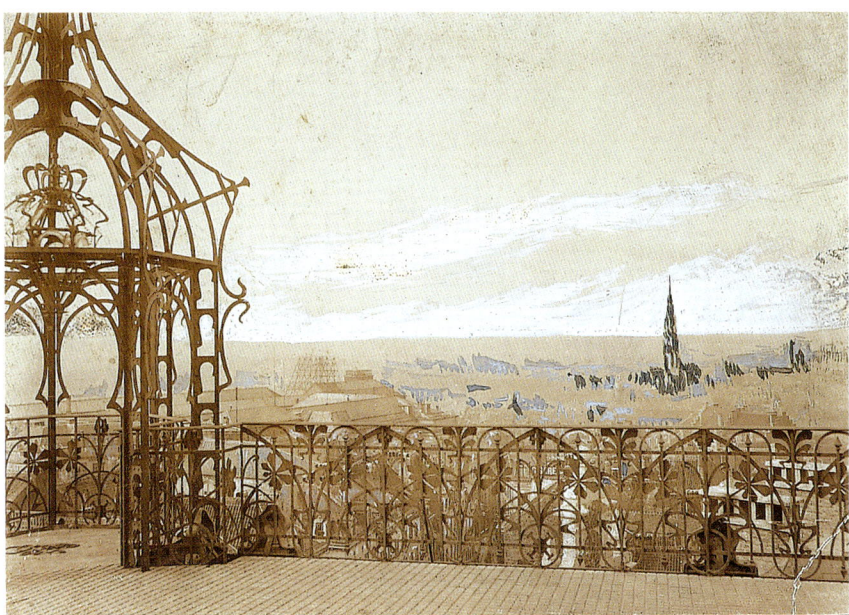

The tea room terrace and corner turret of the Saintenoy building. Old photograph enhanced with gouache.

In the facade, the cruciform steel pillars were replaced by double supports in cast iron, probably chosen for the plastic properties offered by the moulding technique as well as the better corrosion resistance. On each floor the supports adopted a fluid form which at times suggests the Gothico-Renaissance vocabulary – foliated capitals, prismatic mouldings, annulated columnettes – that Saintenoy had used in the project to extend the Dupuich town house and the Delacre pharmacy. The base of the cast iron columns of the ground-floor interior presented a very beautiful motif which translated the traditional theme of the classical dolphin into an almost abstract play of curves. An original solution was also found for the evacuation of rainwater: the cast iron facade supports were given a concave external profile to house the cylindrical downpipes.

With a sense of the fusion of forms characteristic of art nouveau, the main facade offered an original combination of the idea of the oriel (the plastic potential of which Saintenoy was able to appreciate when restoring the Ravenstein town house), the gable and the dome. However, special dispensation from the building regulations was going to be necessary to construct the large oriel 1.10 metres deep rising over three floors and supporting the terrace tea room. This was linked to the first floor by two oblique cast iron columns which were directly inspired by the models published in the 12th chapter of the *Entretiens sur l'architecture* of Eugène Viollet-le-Duc (1872), although they

Advertisement for the Pierre Desmedt ironworks.
L'Émulation, 1895.

Vermeren-Coché porcelain
and ceramics price list, 1889.

do not fulfil exactly the same support function as in this case the column is suspended from the oriel.[40] On the corner of the rue Villa Hermosa, the unsubstantial curve of the new street line was given form by a surprising turret with a heptagonal plan culminating in a flamboyant openwork cap.

The delicacy of the metal frame was one of the structure's principal attractions, transforming the interior into a genuine glass cage in which the merchandise was bathed in natural light. It was only on the top floor, devoted to sewing rooms, where the openings were limited to a band of high narrow windows. The original plans as submitted for approval to the authorities also involved natural lighting for the basement by means of *Hayward & Eckstein* solid glass blocks laid out in a strip 50 centimetres wide along the pavement and in a part of the ground floor left bay, but the idea was abandoned at the construction stage.

The transition to the pavilion on the place Royale was provided by decorating the party wall profile with blue stone rustication topped with an obelisk, as a kind of ironical and condensed version of the century of eclecticism which separates the neo-classical square from the art nouveau store. As soon as the new building was inaugurated, the terrace and its tea room proved immediately – and lastingly – popular with a fashionable clientele: *You are carried up in the lift, then, suddenly, at 23 metres from the ground, the lift cage suddenly opens out and you are greeted with the most*

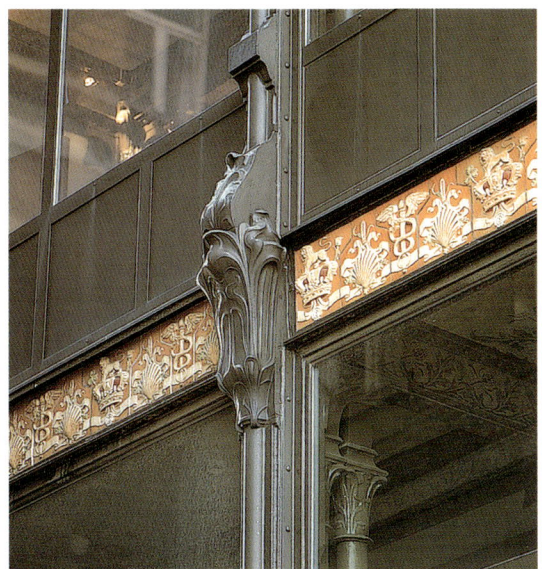 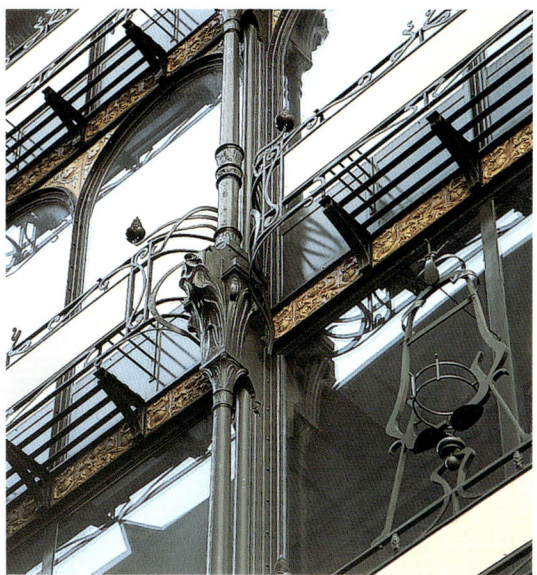

Saintenoy building, detail of the ground floor and second floor of the rue Villa Hermosa facade after restoration. Photographs Ph. De Gobert, 2000.

remarkable view. The panorama embraces the whole of the Brussels conurbation beneath which the underground lines will soon be burrowing. The whole of Brussels high society is to be found there between 4 and 6. The five o'clock tea is particularly splendid, the sounds of the concerts in the park arriving in harmonious breaths.[41] Thirty years later Albert Guislain evoked the atmosphere once more with great affection and nostalgia in *Bruxelles Atmosphère: The waltz was in fashion. One played its forms like the strings of a violin, with the expressive "portamento" voluptuously curving the lines. The creator's pencil refined and traced the curves of skaters on ice [...] One must not hold in disdain this preparation for the constructivism which was to manifest itself after the war. Also, was not the Old England terrace the five o'clock of the beautiful days of 1910 or 1911, the panorama of a city which has ceased to be. Pointillism was all the rage, the women wore pretty boleros and chinchilla furs and the ironwork adopted the gracious forms of thistles or leaves.*[42]

 In front of the facade itself, Saintenoy designed a fine latticework of openwork balconies allowing access to the windows for cleaning or maintenance. This particularly modern idea prefigured the facade of Victor Horta's Innovation building (1901) and Van Neck's clinic by Antoine Pompe (1910). The abundant ironwork with its interplay of broad and thin lines was produced by Pierre Desmedt's workshop on the rue Mercelis in Ixelles. He worked regularly with Paul Hankar,

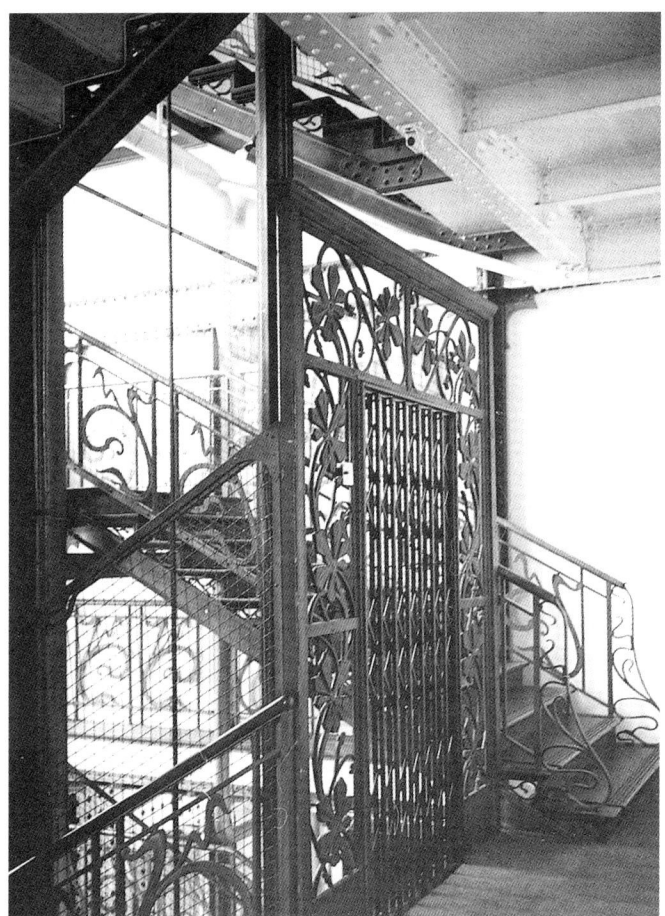

Saintenoy building lift and stairs.
Old photograph Fiamma Vig, no date.

Victor Horta as well as for Paul Saintenoy, for whom he produced the forged iron for the Hasselt Provincial Palace (1896), the Roux mirror company pavilion at the 1897 international exhibition and the De Pauw town house on the rue du Taciturne in Brussels (1900).[43] On nearly every floor the patterns embraced the monogram, probably golden, formed by the Old England initials.

The colouring of metal architecture, both internal and external, had been the subject of frequent experiments during the second half of the XIXth century. Examples include the juxtaposition of the primary colours yellow, red and blue separated by white strips at the Crystal Palace at the London World Exhibition in 1851, the grey-blue tones of many turn-of-the-century Parisian

facades, the "veau en Bellevue colour of the restaurants" for the Eiffel Tower at the 1889 World Exhibition, the bright red of the structural elements of the concert and conference hall at the Brussels Maison de Peuple.[44] The rather uncustomary shade Saintenoy chose for the facade – a very dark brownish green – seems to have been mainly dictated by the shop's commercial strategy: it allows the building to contrast sharply against the light neo-classical shades of the place Royale and neighbourhood. Like the green forged irons of Horta's first buildings, it also discreetly stresses the plant inspiration of the decoration.

In keeping with the ideas of Viollet-le-Duc, Saintenoy combined the metal structure of the facade with an infill of enamelled vitrified clay covering the girder webs, the window quoins, the top floor spandrel and the lower surface of the cornices. Produced in shades of orange and ochre by Vermeren-Coché enterprises – which produced the facade at 29 boulevard Général Jacques adorned with daisy patterns and the company's very attractive facade at 143 chaussée de Wavre in Ixelles[45] – the tiles evoked both commerce and the various regions of Great Britain or the British Empire from which the shop's merchandise originated. The first floor frieze presented an alternating pattern of Aesculapius's staff, as the symbol of commerce, shellfish no doubt to evoke travel, and the British Crown surmounted with a lion and the surround of an English rose, the Irish clover and the Scottish thistle. The second and third floor friezes were composed of poppy pods and flowers; the fourth floor frieze of oak leaves and acorns surmounted with the coat of arms of Great Britain with the three golden lions passant of England, the golden lion against a mouth background of Scotland and the golden harp against the blue background of Ireland. Finally, each balcony supported a ceramic panel, its golden letters stating in French or English – due to the dictates of fashion – the shop's principal departments.

The late XIXth century discovered the fascinating power of nocturnal electric lighting. For the Maison du Peuple, Horta had envisaged building a dome covered in red glass bricks which, when illuminated from the interior on celebration days, would have been visible from throughout the city.[46] Frantz Jourdain used a similar idea for the glass brick dome which topped the corner rotunda of La Samaritaine in Paris. At Old England, the open crown of the turret housed a large suspended lantern which dominated the whole district like a lighthouse lamp. In front of the second floor windows large metal supports were placed which seemed to have been designed to contain luminous globes[47] – an idea already present, in a different form, in the plans submitted for a building permit, and which was found several dozen metres away on the facade at 72-74 rue Coudenberg, built in 1909 by Gustave Hubrecht.[48]

The very sober interior decoration fully highlighted the riveted steel structure in a slightly lighter shade of the facade colour. At the top of the crossed pillars four cast iron decorative elements were placed, their fluid form softening the rigidity of the orthogonal network of girders. The ground

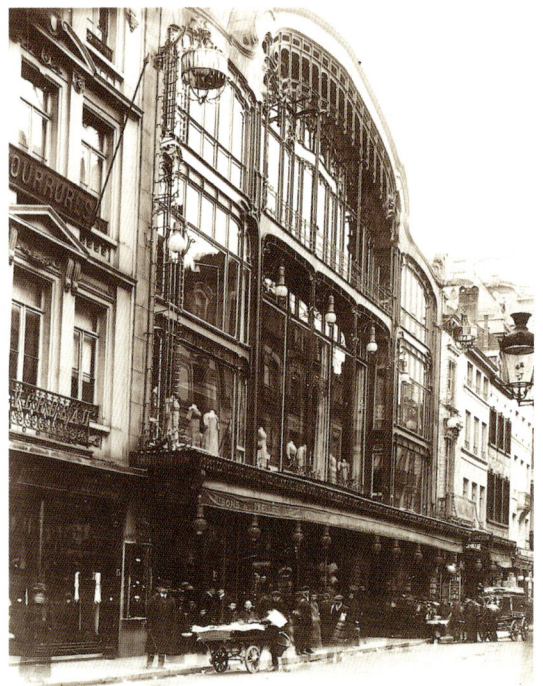
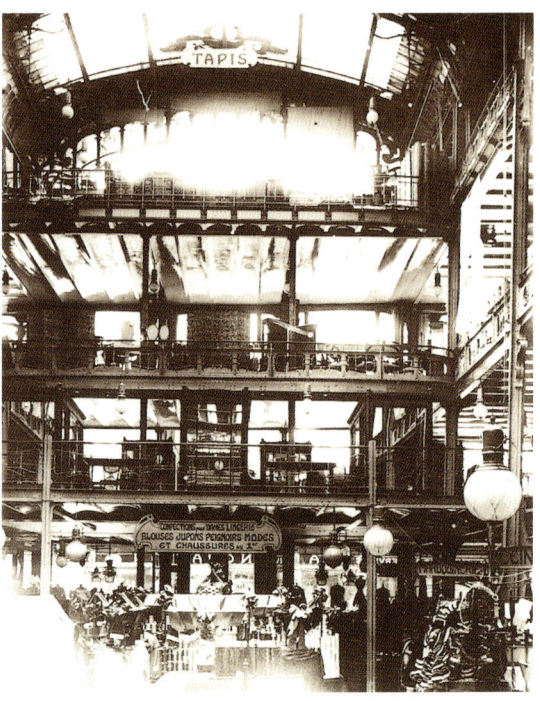

Victor Horta, the Innovation department store, rue Neuve, Brussels, 1901 (destroyed).

Victor Horta, interior of the Innovation department store, rue Neuve, Brussels, 1901 (destroyed).

floor was decorated with thistle motifs, the symbol of Scotland which is where Old England originated, painted in stencil on the ceiling and on the girder web. The stairwell and lift decoration were based on the theme of the Indian chestnut tree, perhaps chosen as the symbol of the most important colony of the British Empire. Its distinctive foliage adorned the cast iron panels which framed the lift and the painted girders around the stairwell, continuing out onto the terrace balustrade. The interior was lit with suspended globes which can be seen on various photographs of the time.

The exact sources and influences for the building, one of the first of its kind in Europe, would merit detailed study. Although featured in French, English and German journals,[49] Old England was hardly mentioned in the Belgian specialist press. Following the experience of the Maison du Peuple, Victor Horta also turned his attention to department stores with a metal structure in 1901, creating the Innovation store on the rue Neuve in Brussels (destroyed). Paul

THE SAINTENOY BUILDING

Paul Jaspar, Galeries du Pont d'Avroy in Liège, 1905 (destroyed). Vers l'Art, 1907, n° 107.

André Gutton, Le Grand Bazar on the rue de Rennes, Paris, 1906 (destroyed).

Jaspar, another fellow student of Saintenoy at the Brussels Academy of Fine Arts, produced the Galeries liégeoises on the boulevard d'Avroy in Liège in 1905 (destroyed). In Paris, in 1903-1904 Frantz Jourdain drew the plans for La Samaritaine. André Gutton, who in 1900 had already built in the rue Saint-Jean in Nancy an elegant small corner building with a shop with a visible metal structure, went on to build the Grand Bazar on the rue de Rennes in 1906 (destroyed).

The fad for commercial buildings with a metal facade was, however, to prove short-lived. While Saintenoy was producing Old England, the technique of reinforced concrete arrived at maturity and was rapidly adopted by most department stores. Saintenoy himself, continuing his research on avant-garde techniques, designed in 1899 what is considered to be the first apartment building constructed entirely in reinforced concrete in Belgium, just a few hundred metres from Old England higher up on the new rue Coudenberg (destroyed).

After the Old England company vacated the premises, the shops were occupied for a number of years by the Rêve d'Orient company. In 1979 they were bought by the Department of National Education and then in 1983 ceded to the Régie des Bâtiments de l'État (Buildings Department) with the intention that they should be home to the Musical Instruments Museum.[50]

Created in 1877 on the initiative of King Léopold II as an offshoot of the new Brussels Royal Conservatory of Music, the collection initially consisted of 80 ancient or exotic musical instruments which the famous musicologist François-Joseph Fétis (1784-1871) had bequeathed to the Conservatory on his death as well as the 97 Hindu musical instruments presented to the King by the Rajah Sourindro Mohun Tagore. After a century of acquisitions, it is today one of the principal museums of its kind anywhere in the world, with more than 7,000 exhibits. The very diverse collection presents a vast panorama of instrument-making as practised in all ages and in every culture, with a number of unique pieces which are of exceptional scientific interest.

Originally housed in the Conservatory loft, the Museum and its collections later took up residence at a number of locations in the Petit Sablon area, none of them being really suited to its needs. In 1927 it was moved to the corner of the rue de la Régence and the square du Petit Sablon, in the former residence of the Conservatory director. Over the years as the collections grew and the activities increased, a series of old houses in the rue aux Laines were progressively annexed. The Museum's administrative status – i.e. an auxiliary educational establishment linked to the Conservatory – only allowed it to operate with a limited number of scientific staff without permanent status.

The joint project to house the Musical Instruments Museum in the former Old England premises and to recognise it as a fourth department of the Royal Museums of Art and History – effective as from 1992 – provided it with the conditions and operating resources of a scientific institution and finally allowed it to develop its museological and artistic activities to the full.

The Régie des Bâtiments, the building owner, entrusted the renovation project to three architecture firms who set up a joint venture for the purpose: GUS of Brussels (François Terlinden, Danny Graux, Georges Vanhamme, architects and town planners), G+D Dirk Bontinck of Ghent (architect) and IDPO Philippe Neerman & Co in Marke (industrial designer).

The programme was drawn up in cooperation with the three successive managers of the Musical Instruments Museum, namely René de Maeyer, Nicolas Meeùs and Malou Haine. The Régie des Bâtiments was responsible for site management, under the direction of Roland Desaever.

The former Old England stores before restoration, 1990.

The Museum consists of three buildings of different origins which form an almost regular quadrilateral approximately 31 metres wide and 47 metres long: the neo-classical town house on the place Royale, the metal Saintenoy building on the corner of the rue Villa Hermosa and a new construction in the rue Villa Hermosa.

The first phase of the works began in November 1989, shortly after the royal decree published in the *Moniteur Belge* (Official Gazette) of 30 March 1989 which listed and authorised renovation works on the Saintenoy building.[51] GUS was responsible for drawing up the preliminary design and most of the restoration works on the art nouveau building, while Bontinck principally

THE MUSICAL INSTRUMENTS MUSEUM

Above and left:
*The Saintenoy building before restoration, 1985.
Photographs* GUS.
• *Views of the ground floor with detail of a cast iron column covered in wood panelling.*
• *View of the 4th floor towards the place Royale building.*

Opposite page:
Detail of the Saintenoy building facade before restoration.

THE MUSICAL INSTRUMENTS MUSEUM

designed the shell and IDPO was charged with finishing works and interior lay-out. Completed in 1994, this first phase included the almost complete external and partial interior renovation of the art nouveau building as well as of the shell of the place Royale building and the rue Villa Hermosa annexe. Phase two of the works (1996-1998) included all the technical installations, finishing and reconstitution of the two interiors in the Guimard building. Phase three (1999-2000) was devoted to various finishing works and fixtures, such as the showcases, counters, library, laboratory, etc.

Right from the start, the intention had been to have the main entrance on the rue Montagne de la Cour in the metal Saintenoy building, which was *intended in particular to avoid any confusion with other museums with their entrance on the place Royale. The art nouveau building is also without a doubt the most lyrical in architectural terms and will help confirm the image of the Musical Instruments Museum.*[52] Problems of heat and sound insulation and fire protection were also considerably simplified by virtue of this solution. The fire separation and insulation of the Saintenoy building is located at the point of contact between this building and other sections of the Museum rather than on the facade.

The Saintenoy building, which is the Museum's backbone, is mainly given over to access and circulation. Around the stairwell with lift the various floors adopt an open-style planning with reception area, bookshop, art shop, exhibition area devoted to the building's history and to Saintenoy, and the concert hall lobby. A playroom known as "Orpheus' Garden" is to be found in the basement where children can explore the world of sound. The sixth floor has been restored to its original function as cafeteria with a terrace enlarged to cover a large part of the roof of the place Royale building.

An initial design had proposed installing the Musical Instruments Museum in the place Royale building while conserving the greater part of the former shop premises.[53] But following a detailed examination, the specific requirements of the Museum and reasons of stability resulted in the decision to totally reconstruct the building interior which had already been virtually totally "emptied" and reconstructed during the transformations of 1905 and 1913. The facades were faced with concrete with buttresses providing considerable heat inertia to reduce temperature and humidity fluctuations and exercise a major buffer effect. No shoring in the traditional meaning of the word was used. The existing central core and girders were retained provisionally while the shell was being placed and then removed when the latter's stability was assured. On the interior courtyard adjoining the former Cour des Comptes a new stone facade with three bays was added to the side facade of the pavilion on the place Royale.

New floorboards were laid on the original levels. Between these floors of considerable height two mezzanine floors were added which look out on the principal floors. The exhibition rooms occupy most of the space, totalling 3,000 m^2 on four floors. The basement is mainly used for

THE MUSICAL INSTRUMENTS MUSEUM

Ground floor of the Saintenoy building after restoration, cast iron column base with dolphin motif.
Photograph Ph. De Gobert, 2000.

THE MUSICAL INSTRUMENTS MUSEUM

THE MUSICAL INSTRUMENTS MUSEUM

Opposite page:
A B C D: *initial state, stages in the works, final state.*
1. *Central core and principal girders retained for shoring of facades.*
2. *Slope on courtyard side.*
3. *Provisional wind bracing of the Saintenoy building before removal of party walls.*
4. *Girder temporarily underpinning the gable of the Saintenoy building.*
5. *Access slope to site.*
6. *Concrete shell initially serving as stiffener.*
7. *Concrete belt girder (starting element for fourth floor).*
8. *Metal girder completing the provisional wind bracing device.*
9. *Lift cage.*
10. *Stairwell.*
11. *Level 2 floor (exhibition area).*
12. *Goods lift shaft.*
13. *Level 2 floor (store room).*
14. *Corner turret.*
(documents GUS).

Above and right:
Ground floor plan and cross-section of the Musical Instruments Museum.
A. *Guimard Building.*
B. *Saintenoy Building.*
C. *Stores.*

▨ *Exhibition areas.*

(documents GUS).

THE MUSICAL INSTRUMENTS MUSEUM

Brass instruments used at the opera during the latter half of the XIXth century: Aida trumpet, saxhorns, Wagner tubas and horns. Photograph Ph. De Gobert, 2000.

temporary exhibitions, an acoustic laboratory and auditorium. The permanent exhibition rooms, on the ground, first and second floors, present a collection of some 1,500 instruments. Two features dating back to the interior reconstruction carried out by Old England in around 1913 have been reconstituted here: on the ground and first floors the former marble staircase with its mahogany showcases and galleries which give onto the two place Royale entrances; on the second floor, a room decorated with marble, mirrors and moulded panelling which houses rare or precious instruments. On the third floor there is a specialist library with several thousand works and on the fourth floor offices for scientific and administrative staff, restoration workshops and a photographic studio. On the top floor there is a 200-seat concert hall.

The scenography of the exhibition areas was entrusted to ÉO Design Partners (Jacques Bodelle and Winston Spriet). The rooms propose a historical, geographical and technical tour of the

*The Musical Instruments Museum concert hall.
Photograph Ph. De Gobert, 2000.*

collections. Attention is focused on the instruments by a presentation which is both sober and warm, using maple wood from Canada and wenge. The visual presentation of the instruments respects vigorous conservation conditions with optical fibre lighting. Visitors are also issued with infra-red headphones to appreciate the real sound quality of the instruments.

It was already apparent when the study group first met that the former Old England buildings would not be able to house all the collections and functions of the Musical Instruments Museum. It was therefore decided to build a new adjoining structure in the rue Villa Hermosa, behind the Saintenoy building. This mainly houses the reserves of instruments which cannot be exhibited in the exhibition rooms, whether due to lack of space, their fragility or their too exclusively documentary interest. This building has a large lift which allows the instruments to be carried up to all the Museum's floors and in particular the concert hall.

THE RESTORATION OF THE ART NOUVEAU BUILDING

As so often, the basic options on the use to which the building would be put had a considerable effect on the nature of the restoration. The decision to use the Saintenoy building as an "annexe" to the museum itself, by making it the place of public access, vertical circulation, reception, sale and relaxation areas, made it possible to avoid the demands which would necessarily have been associated with a music function, in particular the delicate matters of air conditioning and fire resistance. This use also limited the need for partitioning and allowed the open planning of the former shop to be retained. Using the art nouveau building for visitor access meant it was important to show the building off to best effect and immediately prompted the Régie des Bâtiments and architects to envisage restoring the facade to its original state. Despite these favourable auspices, restoring the building proved a complex exercise, in historical, technical and aesthetic terms. Documentation contemporary with the building's construction 100 years previously was in short supply. The archives of Paul Saintenoy have still not been found, and neither have those of the entrepreneur, the builder of the metal structure or the ironworker. Finally, the plans for the building permit conserved at the Brussels City Records Office differ greatly from the building which was ultimately built. What is more, the exceptional nature of the Old England building in relation to Saintenoy's work and the history of architecture in Belgium offers few points of comparison.

For the facade, disfigured by successive mutilations and a long period of abandonment, the basic principle was to restore it as much as possible to the original state as created under the supervision of Saintenoy, while making *reasonable sacrifices to present safety and stability criteria and stopping at the point where interpretation begins*. The serious corrosion of exterior metal elements, the result of exposure to bad weather and a mediocre surface protection, made it necessary to completely disassemble the two facades. Some very damaged bearing structures were replaced while the assembly of the various materials was improved to ensure a longer life for the structure. It also proved necessary to strengthen the dome supports. The windows were fitted with new metal frames and double glazing.

The many metal elements which had disappeared over the years – the large ground-floor awning, the corner turret and its lantern, the two rostrums at the base of the oriel, most of the

THE RESTORATION OF THE ART NOUVEAU BUILDING

Opposite page:
*Placing of the reconstituted corner turret.
Photograph GUS, 1992.*

Right and below:
*Reconstitution of the turret lantern.
Photograph GUS.*

*Manufacture of the corner turret
Photograph GUS.*

— 49 —

THE RESTORATION OF THE ART NOUVEAU BUILDING

THE RESTORATION OF THE ART NOUVEAU BUILDING

Opposite page:
*Detail of the turret after restoration.
Photograph Ph. De Gobert, 2000.*

Above:
*Project for the reconstitution
of the terrace tea room balustrade. Documents GUS.*

Right:
*Reconstitution of the cast iron elements
which decorate the interior supports.
Photograph GUS.*

— 51 —

THE RESTORATION OF THE ART NOUVEAU BUILDING

THE RESTORATION OF THE ART NOUVEAU BUILDING

ironwork – were redesigned on the basis of a painstaking study of all the photographs of the time which could be obtained. The structure of the guard rail which remained provided some valuable indicators of dimensions, shapes and fixation points for the motifs to be recreated.[54]

The dark green colour of the external metal elements was determined on the basis of studies carried out by the Royal Institute of Artistic Heritage in Brussels. On the inside, the original lighter colour was still visible on some girders.

Many of the vitrified clay tiles produced by Vermeren-Coché had fortunately been conserved beneath the white paint which had covered the facade since the 1930s. The original pieces in good condition were cleaned and put back into place in new metal frames. The other elements were reconstituted, in particular the ground-floor frieze, the various turret elements, the Old England

Opposite page:
Stages in the reconstitution of the two rostrums on the main facade: plans, modelling in clay,
plaster casting and the finished facade element. Document and photographs GUS, photograph Ph. De Gobert.

Above:
Reconstitution of the ceramic Old England sign, 1993.

THE RESTORATION OF THE ART NOUVEAU BUILDING

Reconstitution of a coat of arms and tiles in vitrified clay for the façade, 1993. Photograph GUS.

Reconstitution of the lions' heads in vitrified clay for the frieze beneath the terrace balustrade. Photograph GUS.

Removal of the false ceiling to reveal the original paintings on the ground floor ceiling and girders. Photograph J. Glibert.

The ground floor ceiling and girder paintings after restoration and reconstitution. Photograph L. Somogyi.

Ground floor mosaics after restoration.
Photograph Ph. De Gobert, 2000.

name which dominates the oriel, and the lions head frieze under the terrace balustrade. They were produced using traditional techniques by a workshop in Hungary, on the basis of conserved elements, photographs and the composition of the enamels found in the Vermeren-Coché archives.

On the inside, the wood and stucco decor which covered the pillars and ceilings on several floors was removed to reveal the original metal structure with the thistle and chestnut leaf pattern painted in stencil on the girder web and ground-floor ceiling. The reinforced concrete paving was replaced except on the ground floor where it supports the mosaic flooring. The thistle patterns painted on the ground-floor ceiling were identically reconstituted on canvas. It proved possible to conserve some of the stencil patterns on the girder web.

The decorative elements in cast iron attached to the upper section of the pillars were reconstituted on all floors using moulds of the original elements, some of which were found. The stairwell and lift, intended to ensure vertical circulation throughout the museum, were partially altered to create landings which corresponded to the floors in the place Royale building and the stores in the rue Villa Hermosa. The staircase was refitted while conserving the very beautiful cast iron motifs of the balustrade; the lift was entirely rebuilt.

The quality of the work on restoring the facades was recognised in 1994 when it won the Quartier des Arts prize.

THE RESTORATION OF THE ART NOUVEAU BUILDING

Saintenoy building ground floor after restoration.
Photograph Ph. De Gobert, 2000.

NOTES

1. See Corinne TER ASSATOUROFF, "L'environnement idéal du commerce de luxe", in *Le Quartier Royal*, Brussels, CFC-Editions, 1998.
2. Archives de la Ville de Bruxelles, Travaux Publics 19921 (1893). François Malfait undertook the complete restoration of the building in 1933-1937.
3. Archives de la Ville de Bruxelles, Travaux Publics 19920 (1895).
4. Archives de la Ville de Bruxelles, Travaux Publics 24471 (1896).
5. R. BRION, A. BUYLE, *L'hôtel Ravenstein*, Brussels, Société Royale Belge des Ingénieurs et des Industriels, 1987.
6. Archives de la Ville de Bruxelles, Travaux Publics 18854.
7. Archives de la Ville de Bruxelles, Plans portefeuilles 41.
8. Archives de la Ville de Bruxelles, Travaux Publics 2093 (1898).
9. Archives de la Ville de Bruxelles, Travaux Publics 5406 (1899); J.P. MIDANT, "The Maison Moderne in Brussels, 1899-1901", *Rassegna,* March 1992, pp. 45-46.
10. Archives de la Ville de Bruxelles, Travaux Publics 9861 (1901).
11. Archives de la Ville de Bruxelles, Travaux Publics 3356 (1909).
12. Archives de la Ville de Bruxelles, Travaux Publics 9343 (1910).
13. Archives de la Ville de Bruxelles, Travaux Publics 17057 (1886).
14. *Annexe au Moniteur belge* of 13 May 1886, act 849, pp. 504-506.
15. Archives de la Ville de Bruxelles, Travaux Publics 17055 (1898), Propriétés Communales 429.
16. Archives de la Ville de Bruxelles, Travaux Publics 2569 (1905), 32519 (1905).
17. *Annexe au Moniteur belge* of 7 July 1905, act 3753, pp. 113-116.
18. *Annexe au Moniteur belge* of 31 May-1 June 1897, act 2265, pp. 1007-1008.
19. Notary Georges Jacobs, act of 25 June 1909; notary Alphonse De Brabant, act of 15 September 1909.
20. Notary Georges Jacobs, act of 25 January 1911.
21. Notaries Adhémar Morren and Georges Jacobs, acts of 18 December 1911.
22. Archives de la Ville de Bruxelles, Travaux Publics 31313 (1913).
23. Archives de la Ville de Bruxelles, Travaux Publics 31311 (1913), 31310 (1914).
24. Archives de la Ville de Bruxelles, Travaux Publics 31308 (1914).
25. Archives de la Ville de Bruxelles, Travaux Publics 33565.
26. Archives de la Ville de Bruxelles, Travaux Publics 48296 (1938).
27. Archives de la Ville de Bruxelles, Travaux Publics 65097 (1956).
28. Paul SAINTENOY, "Jean-Pierre Cluysenaar", *Académie royale de Belgique. Bulletin de la classe des beaux-arts*, t. XXVI (1944), 1945, p. 128.
29. Paul SAINTENOY, "Schadde (Joseph-Henri-Martin)", *Biographie Nationale de Belgique*, t. 21, 1911-1913, col. 563.
30. Paul SAINTENOY, "A propos de l'architecture métallique", *L'Émulation,* 1889, col. 187-188.
31. Paul SAINTENOY, "Les coupoles d'Orient et d'Occident", *L'Émulation,* 1890, col. 91-93.
32. Paul SAINTENOY, "Kent-Oxfordshire-Cambridgeshire-Northamptonshire. Architecture & archéologie. Notes de voyage", *L'Émulation,* 1891-1893.
33. Archives de la Ville de Bruxelles, Travaux Publics 17057 (1886).
34. A.D., "Magasins de la Samaritaine à Paris", *La Construction Moderne,* 31 March 1912, pp. 315-317.
35. Saintenoy recalls it himself in *Les Arts et les Artistes à la Cour de Bruxelles*, vol. 3, Brussels, 1935, p. 340. The description published in *Die Architektur des XX. Jahrhunderts*, Berlin, 1906, pl. 202, states that *The owner, a forge master, had demanded a construction completely in iron, and that is why all materials except for iron and steel were excluded from this construction.*
36. Archives de la Ville de Bruxelles, Travaux Publics 2566 (conversion of n° 96 rue Montagne de la Cour, 1895). Originally from Nivelles, Jules De Becker (1847-1906) pursued a double career as architect and liberal politician, being provincial adviser for Brabant and alderman then mayor of Koekelberg (1892-1896); he designed the attractive neo-gothic town house at Braine-l'Alleud (1890-1891), advised by his friend Louis Cloquet; see "Nécrologie Jules De Becker, architecte", *L'Émulation,* 1906, col. 8; *L'hôtel de ville de Braine-l'Alleud 1891-1991*, Braine-l'Alleud, 1991.
37. Archives de la Ville de Bruxelles, Travaux Publics 17055 (1898-1899).
38. Advertisement in *Le Soir,* 21 March 1900.
39. The building permit states 263 m² including the courtyard.
40. Eugène VIOLLET-LE-DUC, *Entretiens sur l'architecture*, volume 2, 1872.
41. *Le Patriote illustré*, Brussels, n° 21, 29 May 1900, p. 321.
42. Albert GUISLAIN, *Bruxelles Atmosphère 10-32*, Paris-Brussels, L'Églantine, 1932, p. 124.
43. On Pierre Desmedt, see "Nos ferronniers. La Maison Pierre Desmedt", *Bruxelles Exposition 1897*, 1897, p. 236.
44. As stated in "La maison du Peuple", *Le Peuple,* 5 April 1899.
45. That became Demeuldre-Coché a few years later; the shops were built by the architect Maurice Bisschops in 1905. Chantal DECLEVE, *Guide des décors céramiques à Bruxelles de 1880 à 1940*, Brussels, 1996.
46. Reported in "La maison du Peuple", *Le Peuple,* 5 April 1899.
47. Photograph of the time published in *Academy Architecture and Architectural Review*, London, 1900, vol. 18, p. 72.
48. Archives de la Ville de Bruxelles, Travaux Publics 59 (1909).
49. *Ferronneries de Style Moderne*, Paris, undated, vol. 1, pl. II; *Academy Architecture and Architectural Review*, London, 1900, vol. 18, p. 72; *Die Architektur des XX. Jahrhunderts*, Berlin, 1906, pl. 202.
50. The property was purchased for the Department of National Education by the act of 5 December 1979; it was transferred to the Régie des Bâtiments by the act of 4 March 1983.
51. Facades and interior structure listed as a monument by Royal Decree of 30 March 1989, *Moniteur belge*, 8 June 1989. The facades of the former Spangen town house had been listed by the Royal decree of 22 December 1951.
52. François TERLINDEN, "Le Musée instrumental de Bruxelles dans les anciens grands magasins Old England", *A+ architecture, urbanisme, design*, Brussels, CIAUD, n° 118, 5/1992, p. 44.
53. *Livre Blanc n° 3 de la campagne et de l'action pour la réaffectation du patrimoine architectural. Bruxelles 1985-1986*, CFC; dossier compiled in April 1985.
54. The building owner expressed the wish not to reconstruct the corner awning so as to retain the possibility of access by way of the rue Villa Hermosa.

THE MONTAGNE DE LA COUR DISTRICT
INDICATING WORKS BY PAUL SAINTENOY

1. Restoration of the Ravenstein town house, 3 rue Ravenstein, 1893.
2. Restoration of a XVIth century house, 1 rue Ravenstein, 1895.
3. Projects to convert the Dupuich town house into a House of Learned Societies, 1896-1899.
4. Delacre warehouses, 10-12 rue Villa Hermosa, 1896.
5. Old England stores, 92 rue Montagne de la Cour, 1898.
6. Delacre Pharmacy, 62-66 rue Coudenberg, 1898.
7. Apartment building with workshop for J. Dubois-Petit, 46 rue Coudenberg, 1899 (destroyed).
8. Apartment building for M. Cahen, 44 rue Coudenberg, 1901 (destroyed).
9. Caisse Générale de Reports et Dépôts, rues des Colonies, rue Montagne du Parc et rue de la Chancellerie, 1910.
10. Temporary shops, rue Coudenberg, rue Ravenstein, rue de la Madeleine and Cantersteen, 1909-1910 (destroyed).

In blue: plan of the quarter circa 1910.
In bold: present road layout.
In red: projects and works by Paul Saintenoy.
In green: temporary shops for the 1910 exhibition.

1888
- Project for constructions in the exhibition gardens for the International Sciences and Industry Competition, held in Brussels in 1888.

1890
- Town house, 22 rue P. Spaak in Ixelles.
- Spreutels family tomb at Ixelles cemetery.

1892-1894
- Conversion of a town house for Baron t'Kint de Roodenbeke, 11-13 rue Ducale, Brussels.

1892-1906
- Limbourg Provincial Government building, 21-23 Lombaardstraat, Hasselt.

1893
- Restoration and conversion of the Ravenstein town house for Mlle de Neufforge, 3 rue Ravenstein, Brussels.
- Works at the château de Lonzée (Gembloux) for E. Mélot.

1895
- Restoration of a small XVIth century house for Mlle de Neufforge, 1 rue Ravenstein, Brussels.

1896
- Project for the reconstitution of the Aula Magna of the former Coudenberg Palace, Brussels.
- Town house for Baron Lunden, 81 avenue Louise, Brussels.
- Ch. Delacre et Cie chemical products warehouse for Ch. Delacre, 10-12 rue Villa Hermosa, Brussels.

1896-1899
- Project to convert the Ravenstein and Dupuich town houses into a House of Learned Societies for the Brussels City authorities.

1897
- Brussels City Hall at the Brussels International Exhibition in 1897.
- Pavilion for the "Société des glaces de Charleroi" of Roux for the Brussels International Exhibition in 1897.
- Conversion of the architect's own home at 123 rue de l'Arbre Bénit in Ixelles.

1898
- Old England department store for J. Goffin, 92 rue Montagne de la Cour, Brussels.
- Justice de Paix, 56 avenue Albert I, Binche.
- Pharmacy for Ch. Delacre, 62-66 rue Coudenberg, Brussels.

1899
- House for P. Flon, place J. Jacobs and rue aux Laines, Brussels.
- House for Mlles Rouleaux, 3 place J. Jacobs, Brussels.
- Two houses for H. Spreutels, 88-90 avenue de la Couronne, Ixelles.
- Apartment house with commercial ground floor and workshop for J. Dubois-Petit, 46 rue Coudenberg, Brussels.
- House for E. Blomme, 27 rue Veydt in Saint-Gilles.

1900
- Town house for Mme De Pauw, 34 rue du Taciturne and rue Joseph II, Brussels.
- Project for a villa with artist's studio for A. Cluysenaar, 17 avenue Hamoir in Uccle.
- Project for The Grain Market, place de Brouckère, Brussels.

1901
- Apartment house for M. Cahen, 44 rue Coudenberg, Brussels.
- Apartment building for M. De Bruyne, 149-153 rue A. Dansaert, Brussels.
- House for Privat Livemont, 64 rue Van Oost in Schaerbeek.

1903
- Conversion of a house for Ch. Saintenoy, 68 rue de la Source in Saint-Gilles.
- Project for the Brussels World Exhibition in 1907 (with Henri Vaes).

1903 circa
- Restoration of the château de Grand-Bigard.

1904
- Conversion of L. Losseau's house, 37 rue de Nimy, Mons.
- Belgian Palace at the Saint-Louis (USA) World Exhibition in 1904.
- Decoration project for the château of comte t'Kint de Roodenbeke in Ooidonk (Ghent).

1905
- Château Le Fy at Esneux (Liège).
- Restoration of the château ter Deck for E. Joly in Tombeek.

1906
- Conversion of the Banque du Comptoir National d'Escompte de Paris, 2-4 rue Montagne aux Herbes Potagères, Brussels.
- Project for a town house, 57 rue des Bataves, Etterbeek.

1908
- Conversion of the town house belonging to M. Clynans-Dewandre on the corner of the rue du Commerce and rue du Luxembourg, Brussels.

WORKS AND PROJECTS BY PAUL SAINTENOY

1909
- Project for the conversion of the town house belonging to the baron du Sart de Bouland, 9 square Frère Orban, Brussels.
- Extension of the Home for the Blind, 142 boulevard du Midi, Brussels.

1909-1910
- Project for a provisional portico at the corner of the rue Coudenberg and rue Ravenstein, Brussels.
- Temporary shops, on the rue Coudenberg, rue Ravenstein, rue de la Madeleine and Cantersteen, Brussels.

1910
- Town house for F. Kegeljan, 74 rue Renkin, Schaerbeek.
- Caisse Générale de Reports et Dépôts, rues des Colonies, rue du Parchemin and rue de la Chancellerie, Brussels.

1911
- Decoration projects for the home of M. Dewandre, boulevard Audent, Charleroi.
- Decoration projects for the home of M. Hervy, 20 rue d'Écosse in Saint-Gilles.
- Restoration of the château de Lalaing in Zandbergen (Alost).

1912
- House for A. Stokvis, 15 rue De Craeyer, Brussels.

1920
- Conversion for the Banque Transatlantique Belge, 2 place du Congrès, and 150-152 rue Royale, Brussels.

1922-1925
- Conversion for the Lever House soap factory, 150 rue Royale, Brussels.

1923
- Restoration of the Church of Notre-Dame-au-Bois.

1926
- Conversion for the Société Générale des Minerais, 31 rue du Marais and 3 rue des Sables, Brussels.

1927
- Project for Le Nouveau Palais, 61-63 rue du Marché aux Herbes, Brussels.

1938
- Competition for the Bibliothèque Albert Ier at the Brussels Botanique (with J. Saintenoy).

1938-1956
- Brussels North Station (with J. Saintenoy and J. Hendrickx van den Bosch).

Instruments of the French court in the XVIIth and XVIIIth centuries: alto (XVIIIth century), lute (1671) and hurdy-gurdy (XVIIIth century). Photograph Ph. De Gobert.

BIBLIOGRAPHY

LEMONNIER Camille and WAUTERS Alphonse, *Le palais de la Ville de Bruxelles*, Brussels, Deman, 1897.

SAINTENOY Paul and VAES Henri, *Avant-projet d'une Exposition Universelle et Internationale à Bruxelles 1907*, Brussels, Bruylant, 1903.

SAINTENOY Paul, Notes de voyage d'un architecte en Amérique, *L'Émulation*, 1909.

DES MAREZ Guillaume, *La Place Royale à Bruxelles. Genèse de l'œuvre, sa conception et ses auteurs*, Brussels, Hayez, 1923.

SAINTENOY Paul, *Les Arts et les Artistes à la Cour de Bruxelles*, 3 volumes, Brussels, 1932, 1934, 1935.

LACOSTE Henry, Notice sur Paul Saintenoy, *Annuaire de l'Académie Royale de Belgique*, Brussels, 1962, pp. 79-100.

BORSI Franco and WIESER Hans, *Bruxelles Capitale de l'Art Nouveau*, Brussels, M. Vokaer, 1971; new edition J.-M. Collet, 1996.

RANIERI Liane, *Léopold II urbaniste*, Brussels, Hayez, 1973.

MARREY Bernard, *Les Grands Magasins des origines à 1939*, Paris, Picard, 1979.

BRUNIN Luc, *Paul Saintenoy. 1862-1952*, thesis for the diploma of architect, Institut Supérieur d'Architecture de l'État. La Cambre, 1982-1983.

Le Musée Instrumental à l'Old England, une priorité culturelle, in *Livre Blanc n° 3 de la campagne et de l'action pour la réaffectation du patrimoine architectural. Bruxelles 1985-1986*, Brussels, Commission Française de la Culture de l'Agglomération de Bruxelles, 1986.

Musée Instrumental. Le projet d'installation dans les anciens magasins Old England, Brussels, Ministère des Travaux Publics. Régie des Bâtiments, 1987.

BRION R. and BUYLE A., *L'hôtel Ravenstein*, Brussels, Société Royale Belge des Ingénieurs et des Industriels, 1987.

VRANCKX André, *Paul Saintenoy. 1862-1952*, thesis for the diploma of architect, Hoger Architektuurinstituut Sint-Lukas Brussel, 1988-1989.

Académie de Bruxelles, deux siècles d'architecture, Brussels, AAM, 1989.

Le Patrimoine Monumental de la Belgique, Bruxelles Pentagone, 1 A-C, Liège, P. Mardaga, 1989, 1993, 1994.

HANEGREEFS Kathleen, *De architekt Paul Saintenoy*, thesis for a degree in the history of art and archeology, VUB, 1989-1990.

DEMEY Thierry, *Bruxelles, chronique d'une capitale en chantier. Du voûtement de la Senne à la jonction Nord-Midi*, Brussels, Paul Legrain/CFC-Editions, 1990.

DE HENS Georges and MARTINY Victor-Gaston, *Académie Royale des Beaux-Arts de Bruxelles, Une école d'architecture, des tendances, 1766-1991*, Brussels, 1992.

A+ Architecture, urbanisme, design, Brussels, CIAUD, n° 118, 5/1992, p. 36-47.

MUGAYAR KÜHL Beatriz, *Les Constructions métalliques du XIX siècle et leur restauration. Cas d'étude: Old England arch. P. Saintenoy*, Master's degree in Conservation, Faculty of Applied Sciences, KU Leuven, 1992.

JACOBS Steve, MALHERBE Alain and MIRKES Christine, "anc. Ets. Old England", in *Le Jardin de la Vierge*, Liège, Espace 251 Nord-Art Contemporain, 1993.

SMOLAR-MEYNART Arlette and VANRIE André (dir.), *Le Quartier Royal*, Brussels, CFC-Editions, 1998.

Le Musée des Instruments de Musique dans les anciens magasins Old England, Brussels, Régie des Bâtiments, 1998.

BUILDING OWNER

Régie des Bâtiments

DESIGNERS

Architecture
GUS (F. Terlinden, D. Graux, G. Vanhamme architects and town planners with the assistance of R. Debacker) of Brussels,
G+D D. Bontinck (W. Govaerts architect) of Ghent,
IDPO Ph. Neerman & Co (industrial designer) of Marke

Scenography
ÉO Design Partners (J. Bodelle et W. Spriet) of Bruxelles

Stability
Verdeyen Moenaert of Brussels

Electricity, heating
Varendonck Vincent of Zwijnaarde

Lifts
ing. W. Wauters, Régie des Bâtiments

Acoustics
ing. H. Fabri, Régie des Bâtiments

WORKS MANAGEMENT

Régie des Bâtiments
Services extérieurs bruxellois
ir H. Evenepoel, general adviser

Building shell and finishing works
Manager-coordinator:
ir R. Desaever
Controller: M. Greffe

Stability
ir Ph. Debacker

Heating
Managing official: ing. G. Claes
ir G. De Bondt (SAPC)

Electricity
Managing official: ing. W. Mangelinckx

Lifts
Managing official: ing. W. Wauters

ENTREPRISES

Shell and finishing works
S.A. Maurice Delens of Brussels
(first and second phases)
S.A. Potteau - Labo of Heule
(third phase)

Electricity
Entreprise Nizet of Louvain-la-Neuve

Heating
SPRL Daeninck & Deweerdt of Bruges

Lifts
S.A. Liften Thiery of Antwerp

CONTENTS

Preface .. 3

The place Royale and the Montagne de la Cour 4

The Old England stores .. 16

The Saintenoy building .. 24

The Musical Instruments Museum .. 38

The restoration of the art nouveau building .. 48

Notes .. 57

Map of the Montagne de la Cour district .. 58

Works and projects by Paul Saintenoy .. 59

Bibliography .. 61

PHOTOGRAPHIC CREDITS:
- Archives d'Architecture Moderne, Brussels: cover, 4, 7, 9 bottom, 11, 13, 23, 33, 36, 37, 41, 43, 46, 47, 50, 52 bottom right, 55, 56, 60.
- Archives de la Ville de Bruxelles: 9 top (TP 19921), 12 (TP 24471), 14 right (TP 9861), 15 (TP 3356), 21 (TP 17057), 26 (TP 17055).
- Crédit Communal de Belgique, Brussels: 6.
- GUS, Brussels (F. Terlinden): 16, 20, 22, 25, 28, 30, 31, 39, 40, 44, 45, 48, 49, 51, 52, 53, 54.
- Institut Français d'Architecture, Paris: 14 left.
- J. Lemercier, Brussels: 5.
- Musée communal de la Ville de Bruxelles: 10.

Printed
in November
two thousand and one
by Futura
of Brussels

Publisher:
Archives d'Architecture Moderne
86 rue de l'Ermitage
1050 Brussels
Tel. 0032.2.642.24.62
Printed in Belgium
Deposit copy: D/2001/7
ISBN: 2-87143-119-1